The Astrophotography Planner

2020-2021 Edition

Charles Bracken

The Astrophotography Planner

by Charles Bracken

Printed in the United States of America

ISBN-13: 978-0-9994709-2-3

Second Edition

(2.0, November 2019)

Contents

Introduction

Knowing when a deep-sky object is optimally placed in the night sky allows you to gather the best possible data for your images. This book will point you to what is best positioned in the sky tonight and help you plan your imaging runs for the optimal time of year for each object.

Here you will find detailed charts and maps for 76 of the best deep-sky objects visible from the northern hemisphere. Each entry is focused on one or two key objects, with detailed charts showing how many hours you can expect to collect good data (weather permitting, of course) and data about where the object is positioned throughout the year. To help you decide how to frame your image, there is also a map of the deep-sky objects in that area.

How to use the charts

All charts were created from the perspective of northern hemisphere observers—specifically, a latitude of 40°N was used as the main basis for the charts, with results for 30° and 50° overlaid via dashed and dotted lines respectively. While your latitude will affect how long a given object spends in the night sky, especially for objects with high or low declinations, it has much less effect on the best time of year to image it.

A threshold of 15° above the horizon was used for the lowest in the sky you'd want to image an object. Below this, atmospheric turbulence can dramatically affect your results. Thus, the rise and set times shown were calculated for when an object is above 15° altitude, not merely above the horizon.

Darkness was defined as when the sun is at least 12° below the horizon. This is the beginning of astronomical twilight, and the sky is almost as dark as it will get for anyone with any light pollution. (A more conservative estimate would be at the end of astronomical twilight, when the sun is 18° below the horizon, but in practice, the 12° threshold is usually a good time to start an imaging run.)

The top chart for each object shows the number of quality imaging hours available for each night of the year. 'Quality imaging hours' are the total time on a given night that an object is at least 15° above the horizon while the sky is dark enough to image. This will help you plan the best nights for capturing an object. If you are closer to 50°N, use the dotted line; if you are closer to 30°N, use the dashed line. Two examples of how to interpret the chart are shown below in **Figure 1**.

The bottom chart for each object shows its rise, set, and transit times relative to the hours of darkness throughout the year. The rise time line has upward arrows and the set time line has downward arrows. (Again, the rise and set times are when it is above 15° altitude, not when it is above the horizon.) The middle line is the time at which the object transits the meridian. Not only does this tell you when to plan your mount's meridian flip, but it's also when the object is highest in the sky, and thus least affected by atmospheric dispersion and turbulence. **Figure 2** shows an example of how to read these charts. Note that times are not adjusted for Day-

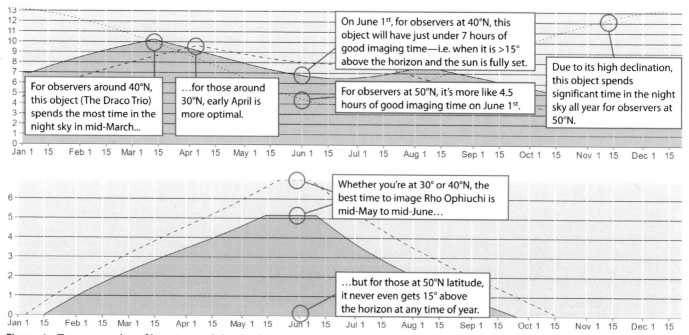

Figure 1. Two examples of how to read the Quality Imaging Hours chart (Draco Trio at top, Rho Ophiuchi at bottom).

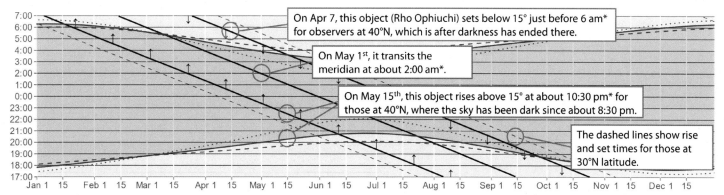

Figure 2. An example of how to interpret the Rise, Set, and Transit chart of each entry (in this case for Rho Ophiuchi)

light Savings Time, so make a one-hour correction in the summer months.

How to use the maps

To help you locate an object and identify surrounding objects, a map is included for each area. With the exception of the map for Barnard's Loop, all maps show a 10°×10° area centered on the object of interest, drawn at a scale of 0.83° per cm (2.1° per inch). By drawing the maps at the same scale, you can get a good sense of the relative size of each object or group.

Emission nebulae are shaded in red, reflection nebulae in blue, and planetary nebulae in purple. Dark nebulae and molecular clouds are shown in light brown. Crossed circles are globular clusters and open circles are open clusters. Galaxies are green ovals and galaxy clusters are shown in green rectangles. All objects are shown at their actual size (to scale) and orientation. Depending on the area, stars are shown down to magnitude 9 or 10.

The field of view (FOV) for some common sensor sizes and focal lengths are shown in the appendix at the same scale as the maps. You can use these with a ruler or copy them onto transparency film to get an approximate FOV to frame your image.

The objects and areas covered

While any "best of" list is inherently arbitrary, the 76 areas shown contain most of the highlights for northern hemisphere imagers. When choosing the objects, the focus was on astrophotography; this would be a very different list if it were for visual observers. The open clusters that fill much of the Messier catalog, while interesting at the eyepiece, are usually not very photogenic. Since electronic imaging makes incredibly faint objects reasonable targets for amateurs, there is a greater emphasis on large nebulae and galaxies where details can be resolved.

A variety of object types and sizes are included. Most of the galaxies and planetary nebulae are small, requiring longer focal lengths (>1000 mm). The larger objects are suitable for moderate focal lengths in the 400-800 mm range. The largest nebulae require either a mosaic-based approach or a camera lens to capture on most sensors. All of the emission nebulae are great for RGB imaging, but most are even better with narrowband filters and mapped color imaging. The emission lines worth imaging are noted in the descriptions.

Common names were used to describe most objects (though there will always be some disagreement about what constitutes "common"). While many nebulae are casually referred to by the Messier or NGC designation of their embedded open cluster, here they are either referred to by their proper nebular catalog designation (usually Sharpless) or a common name. In any case, a list of alternate catalog numbers is provided for the main objects.

The entries are ordered by RA, starting with those with a date of midnight transit on January 1st. **Figure 3** on page 11 shows the location of each area map covered in this book.

The moon's impact on imaging

The moon has a significant impact on when you can image, especially for broadband (i.e. not narrowband) imaging. The following four pages show the hours of darkness available for 2020 and 2021, with the times where the moon is not in the sky shaded. The moon phases are marked along the left edge, with new moons as filled circles and full moons as open circles.

Moonless Dark Hours, Jan-Jun 2020

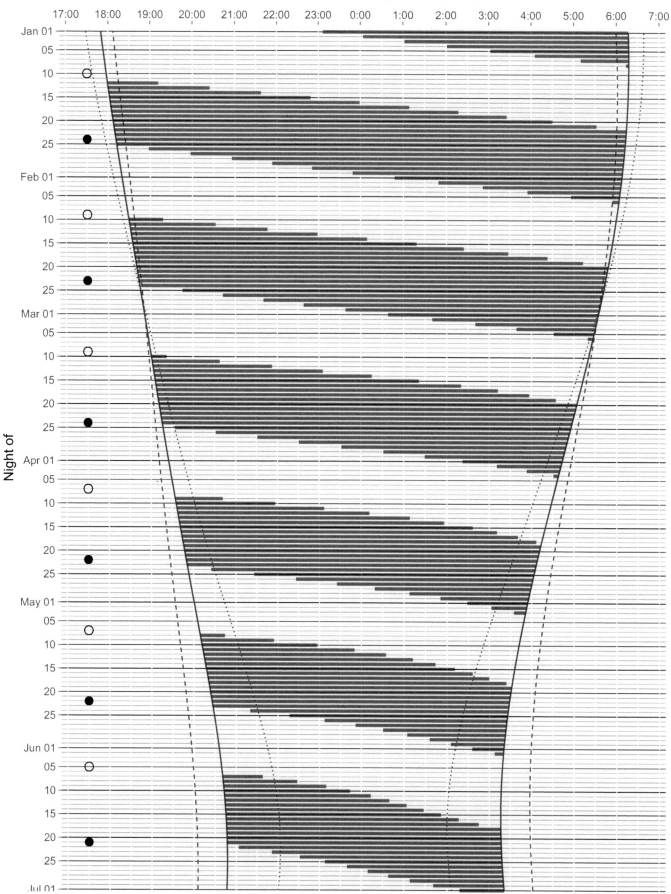

Set/rise lines show when the sun is >12° below horizon. Dark bands are moonless times. Add one hour to times shown during summer for DST.

Moonless Dark Hours, Jun-Dec 2020

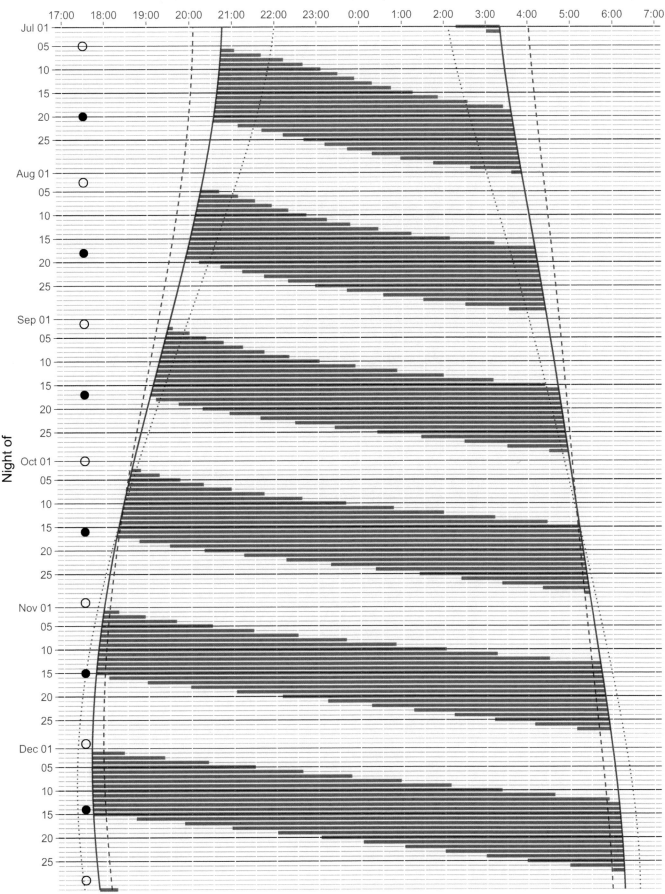

Set/rise lines show when the sun is >12° below horizon. Dark bands are moonless times. Add one hour to times shown during summer for DST.

Moonless Dark Hours, Jan-Jun 2021

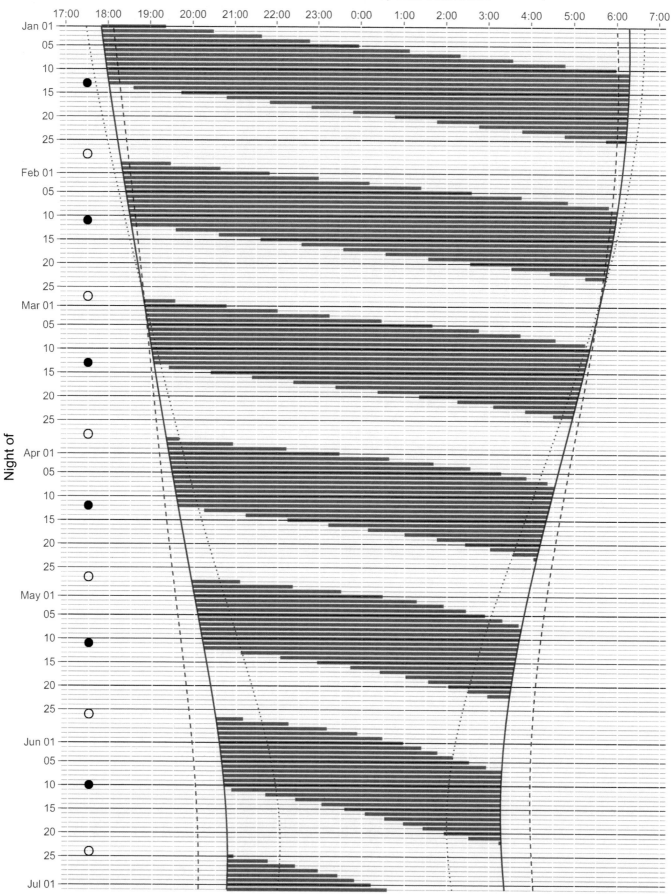

Set/rise lines show when the sun is >12° below horizon. Dark bands are moonless times. Add one hour to times shown during summer for DST.

Moonless Dark Hours, Jul-Dec 2021

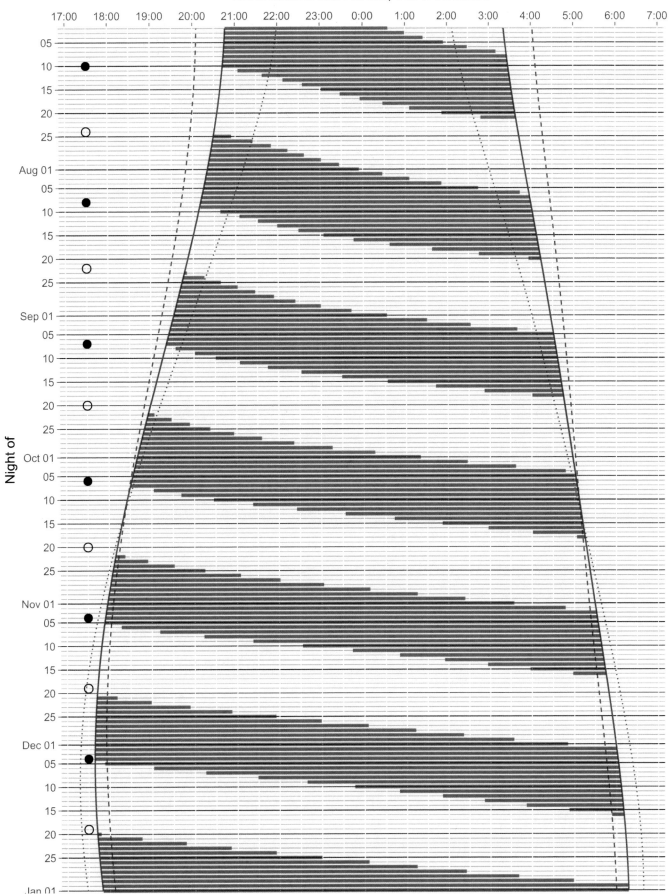

Set/rise lines show when the sun is >12° below horizon. Dark bands are moonless times. Add one hour to times shown during summer for DST.

Object Maps and Charts

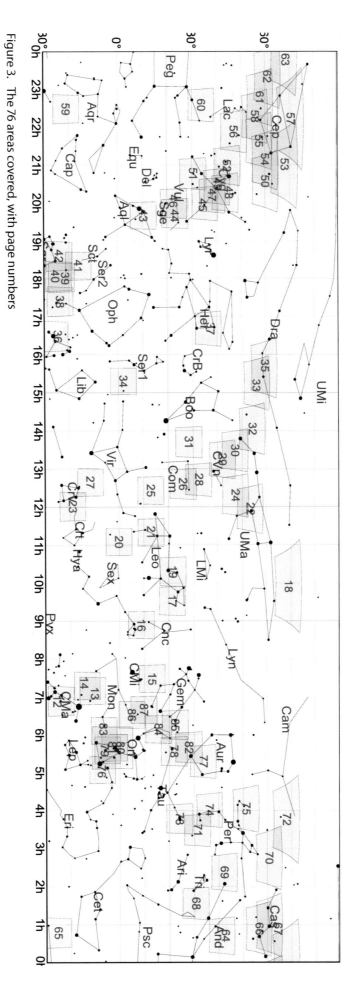

Figure 3. The 76 areas covered, with page numbers

Sh2-308

Type: Emission Nebula

Size: 40'×40'

Coordinates: 06h 54m, -23° 56'

Cataloged as: RCW 11

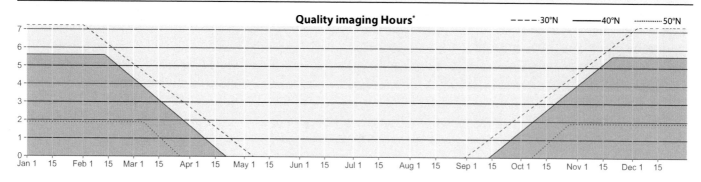

Quality imaging Hours*

- - - - 30°N —— 40°N 50°N

Rise, Set, and Transit Times*

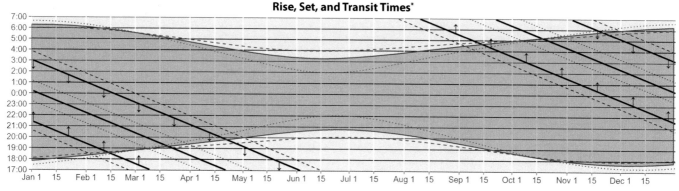

** Rise/set times and total hours are based on the object being >15° above the horizon. Darkness defined as when the sun is >12° below horizon*

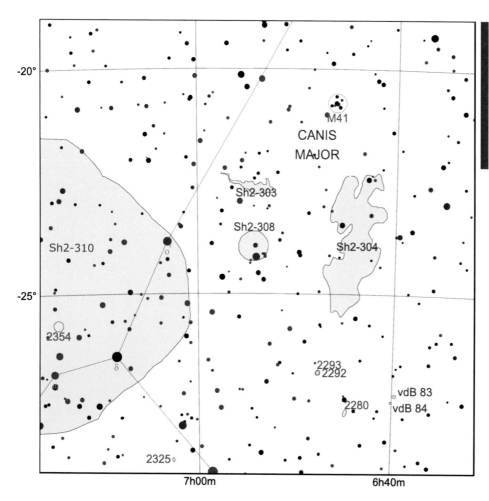

Sh2-308 is definitely a challenge object. It is a half-degree bubble around Wolf-Rayet star WR 6 (EZ Canis Minoris) that emits primarily in OIII, though H-alpha is also detectible. Long narrowband exposures are necessary to reveal a thin, wispy sphere. It can be framed in wider views with nearby emission nebulae.

The Seagull Nebula

Type: Emission Nebula

Size: 2.6°×2.5°

Coordinates: 07h 10m, -11° 00'

Cataloged as: Sh2-296, NGC2327, IC2177, Ced 89B ('body'); Sh2-297, vdB 94, Ced 90 (wing tip); Sh2-292, vdB 93 ('head')

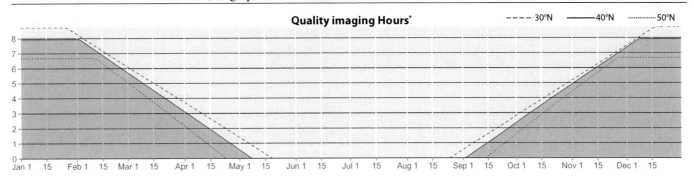

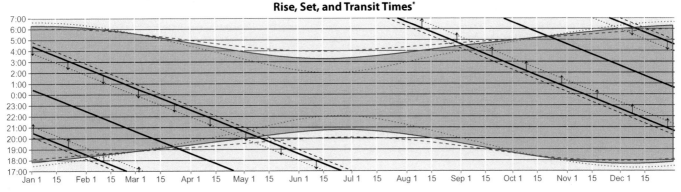

* Rise/set times and total hours are based on the object being >15° above the horizon. Darkness defined as when the sun is >12° below horizon

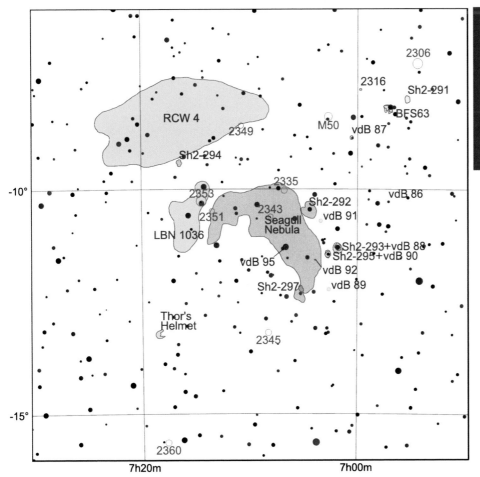

The huge Seagull Nebula is actually cataloged as several different Sharpless objects (Sh2-292, 296, and 297), but together they form a strikingly bird-like object with dense H-alpha, SII, and OIII emissions that makes for great mapped-color image. The "head" features a dark dust nebula mouth. OIII is revealed in the wings and head areas.

Thor's Helmet

Type: Emission Nebula

Size: 12'×12'

Coordinates: 07h 18m, -13° 13'

Cataloged as: Sh2-298, NGC2359, RCW 5

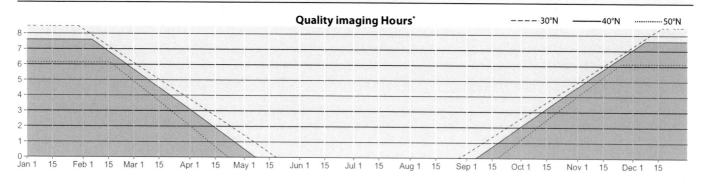

Quality imaging Hours*

— — — 30°N ——— 40°N ·········· 50°N

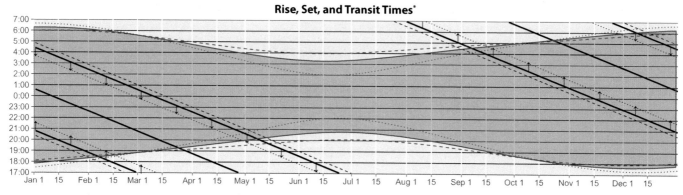

Rise, Set, and Transit Times*

* Rise/set times and total hours are based on the object being >15° above the horizon. Darkness defined as when the sun is >12° below horizon

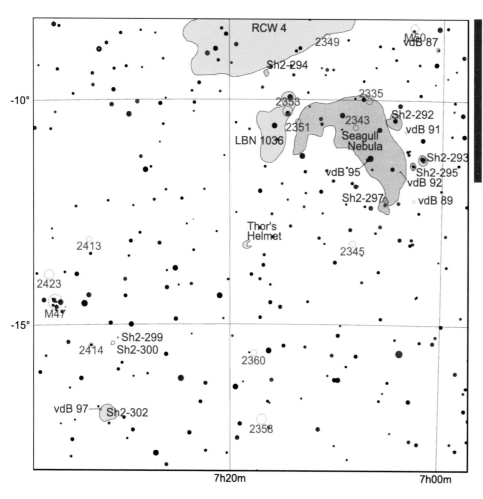

The complex shape of this nebula comes from its shell of gas (shed by the central Wolf-Rayet star) being buffeted by the surrounding molecular cloud. A great RGB target, but even better in mapped-color narrowband. Either way, the blue OIII is actually more prominent than red H-alpha, creating a nicely contrasting image.

14

Medusa Nebula

Type: Planetary Nebula

Size: 20'×10'

Coordinates: 07h 29m, +13° 13'

Cataloged as: Abell 21, Sh2-274

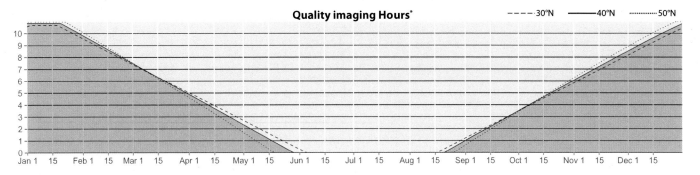

Quality imaging Hours*

30°N · · · · 40°N · · · · 50°N

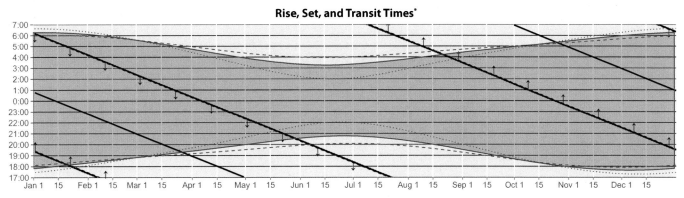

Rise, Set, and Transit Times*

* Rise/set times and total hours are based on the object being >15° above the horizon. Darkness defined as when the sun is >12° below horizon

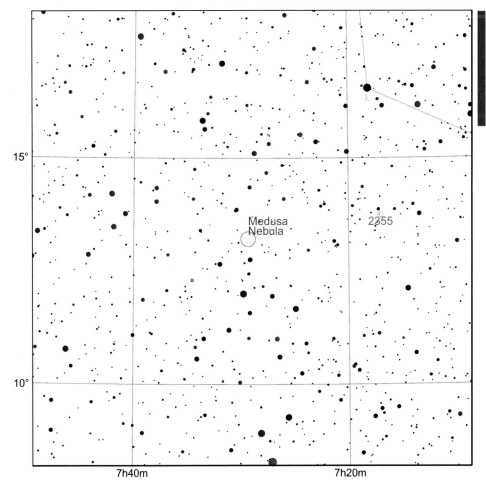

It's hard to see Medusa's face in most images of this old planetary nebula, but it does have finger-like streaks that run from end to end. Use narrowband filters to help enhance contrast. There is an OIII shell, but it is far fainter than the H-alpha.

Abell 31

Type: Planetary Nebula **Coordinates:** 08h 54m, +08° 55'

Size: 32'×16' **Cataloged as:** Sh2-290

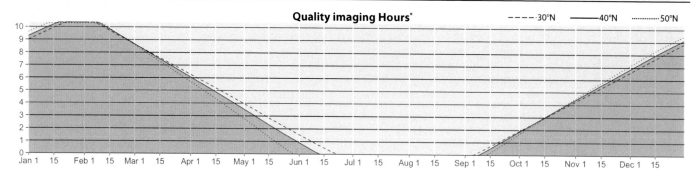

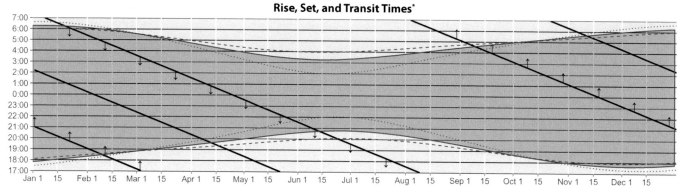

* Rise/set times and total hours are based on the object being >15° above the horizon. Darkness defined as when the sun is >12° below horizon

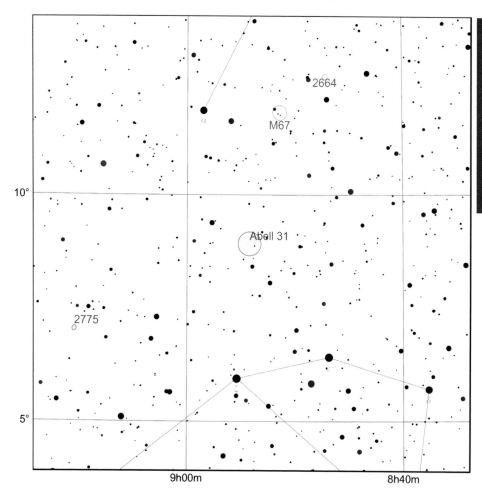

Number 31 is the largest planetary nebula in the Abell catalog, but like all Abell nebulae, it's very dim. It is roughly spherical with a bright OIII core, surrounded by H-alpha. Great color contrast is possible in long narrowband exposures. Like many planetaries, it has a distinct NII emission line, but most H-alpha filters with a bandpass of 5nm or greater will capture it together with the H-alpha signal.

16

NGC2903

Type: Galaxy

Size: 13'×6'

Coordinates: 09h 32m, +21° 30'

Cataloged as:

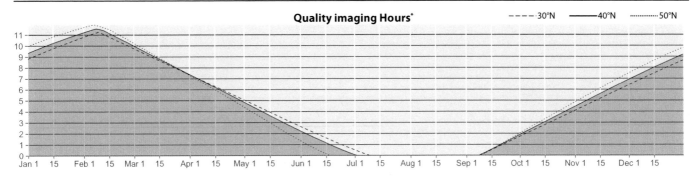

Quality imaging Hours*

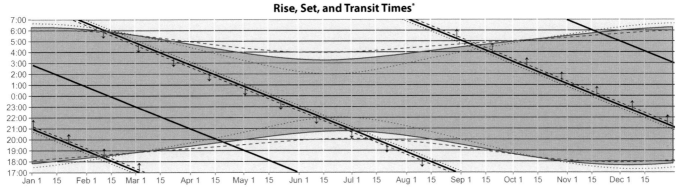

Rise, Set, and Transit Times*

* Rise/set times and total hours are based on the object being >15° above the horizon. Darkness defined as when the sun is >12° below horizon

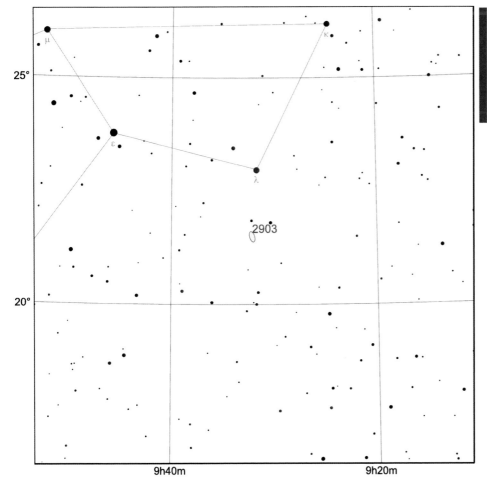

NGC2903 is a standout among the many galaxies in Leo. It's a fine barred spiral galaxy with HII areas in the core and long (but faint) outer arms. Longer focal lengths and steady seeing are required to reveal detail in the core.

Type: Galaxy Group **Coordinates:** 09h 55m, +69° 03'
Size: 27'×14' (M81), 11'×5' (M82) **Cataloged as:** NGC3031 (M81), NGC3034 (M82)

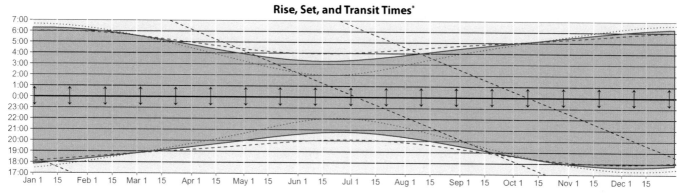

Quality imaging Hours*

Legend: ----- 30°N ——— 40°N ········· 50°N

Rise, Set, and Transit Times*

* Rise/set times and total hours are based on the object being >15° above the horizon. Darkness defined as when the sun is >12° below horizon

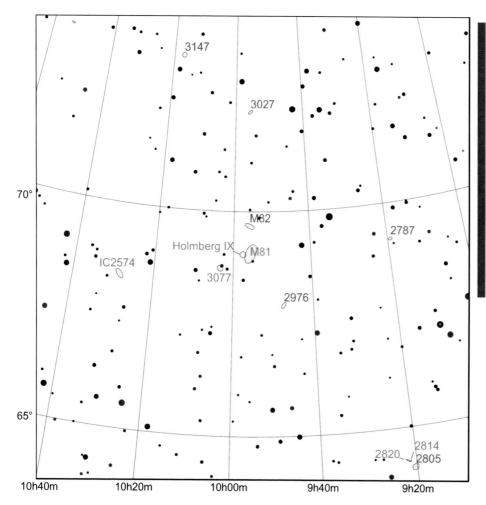

Sometimes called Bode's Galaxy after its discoverer, M81 is a large, bright spiral that reveals tremendous detail at long focal lengths. Wider fields can capture M82 and/or NGC3077 as well. M82 is usually thought of as the companion to larger M81, but it's worth imaging on its own. H-alpha images reveal strong HII emission around core. Dwarf galaxy Holmberg IX is a satellite of M81, and visible in longer exposures on the east side. Because they are so far north in declination, these galaxies can be imaged year-round, though February is when they spend the most time close to the zenith.

18

The Hickson 44 Galaxy Group

Type: Galaxy Group

Coordinates: 10h 18m, +21° 47'

Size: 16'×12'

Cataloged as:

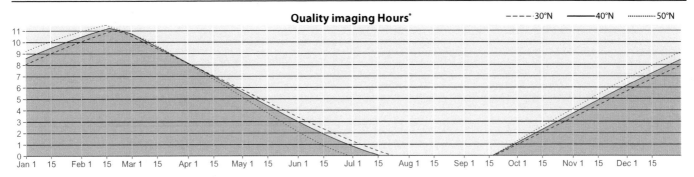

Quality imaging Hours*

- - - - 30°N ——— 40°N ·········· 50°N

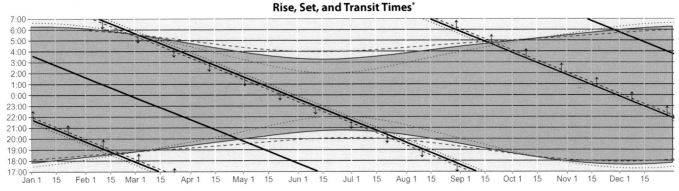

Rise, Set, and Transit Times*

* Rise/set times and total hours are based on the object being >15° above the horizon. Darkness defined as when the sun is >12° below horizon

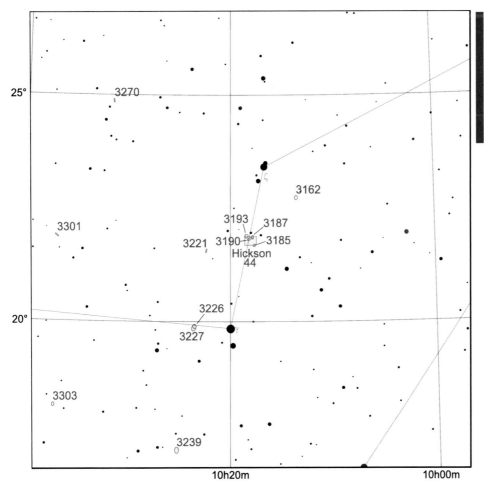

Hickson 44 is a spectacular galaxy group that offers a lot of variety in a small area for those with the focal length to resolve it. The cluster includes NGC 3785 (barred spiral), 3187 (spiral with pronounced tidal tails), 3190 (spiral with dust lane), and 3193 (elliptical).

NGC3521

Type: Galaxy **Coordinates:** 11h 05m, -00° 02'

Size: 11'×7' **Cataloged as:**

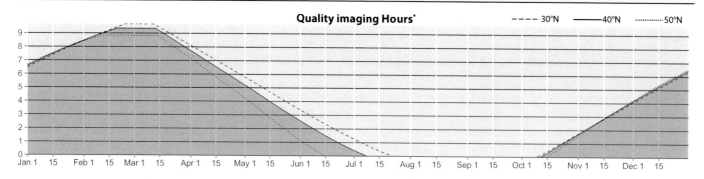

Quality imaging Hours*

– – – – 30°N —— 40°N ·········· 50°N

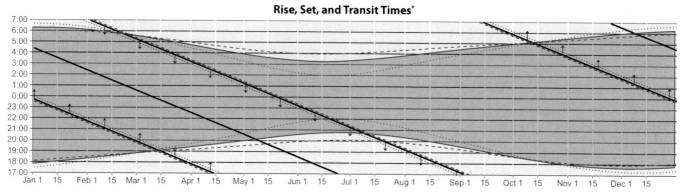

Rise, Set, and Transit Times*

* Rise/set times and total hours are based on the object being >15° above the horizon. Darkness defined as when the sun is >12° below horizon

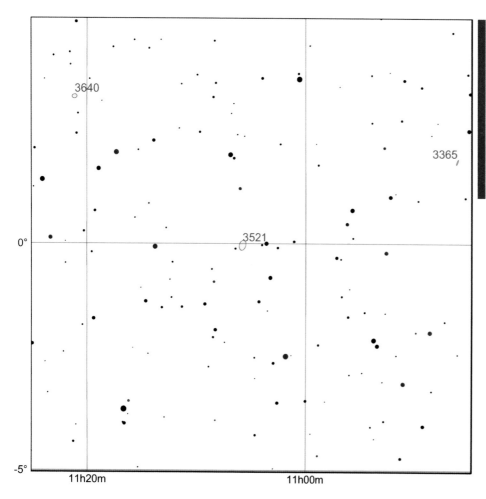

This fairly large flocculant galaxy looks similar to M63, the Sunflower Galaxy. It is rarely imaged, probably due to the nearby Leo Trio drawing all the attention. Extremely long integrations reveal tidal debris around the core from past collisions with other galaxies. It could be a great choice for those with large telescopes looking to capture something different. Sits 2 arcminutes from the celestial equator.

The Leo Trio

Type: Galaxy Group

Size: 50'×40'

Coordinates: 11h 20m, +12° 59'

Cataloged as: NGC3627 (M66); NGC3623 (M65)

Quality imaging Hours*

- - - 30°N —— 40°N ······ 50°N

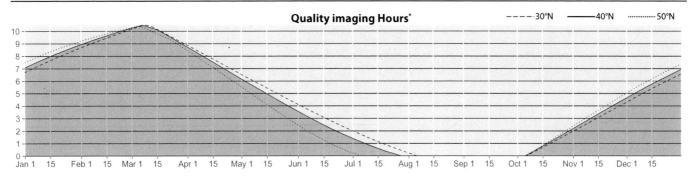

Rise, Set, and Transit Times*

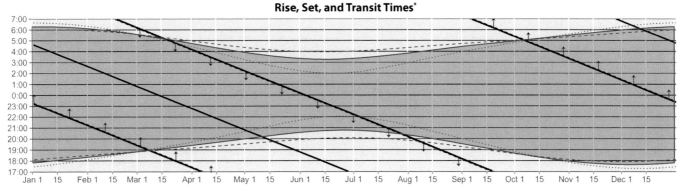

* Rise/set times and total hours are based on the object being >15° above the horizon. Darkness defined as when the sun is >12° below horizon

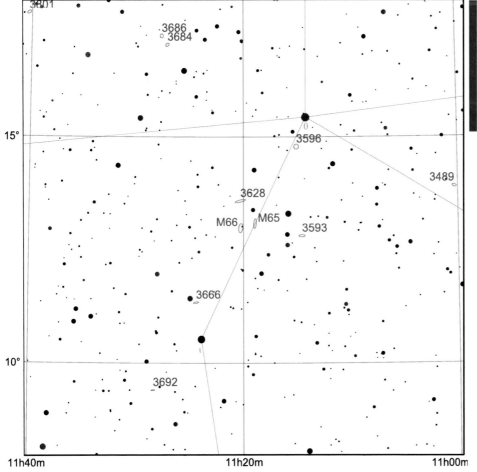

The Leo Trio is one of the most imaged galaxy groups because it features three large and bright galaxies: M65, M66, and NGC 3628, each around 10' across in an area of about 50x40'. NGC3628 is edge-on with prominent dust lanes, while M65 and M66 are tilted to reveal their spiral shapes.

M109

Type: Galaxy **Coordinates:** 11h 57m, +53° 22'

Size: 8'×5' **Cataloged as:** NGC3992

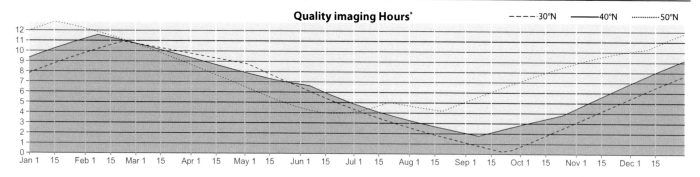

Quality imaging Hours*

- - - - 30°N —— 40°N ····· 50°N

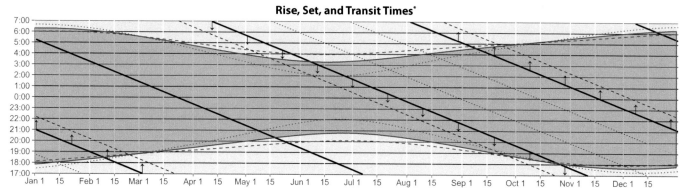

Rise, Set, and Transit Times*

* Rise/set times and total hours are based on the object being >15° above the horizon. Darkness defined as when the sun is >12° below horizon

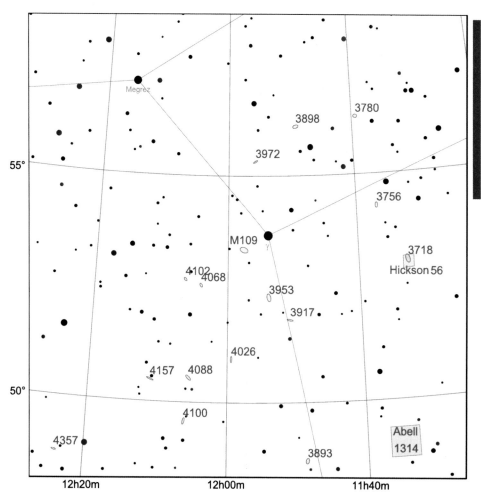

M109 is a small but bright barred spiral. It's the largest of the M109 group, with over a dozen members. Nearest to M109 are faint UGC6969, UGC6940, UGC6923. Fields >1 degree reveal many galaxies, including bright NGC3953 and NGC4102. Watch out for glare from nearby Gamma Ursae Majoris at mag 2.4. M109 is the most distant object in the Messier catalog.

The Antennae Galaxies

Type: Galaxy Group

Size: 30'×30'

Coordinates: 12h 01m, -18° 52'

Cataloged as: NGC4038, NGC4039

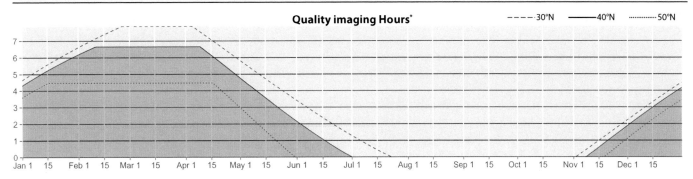

Quality imaging Hours*

- - - - 30°N —— 40°N ·········· 50°N

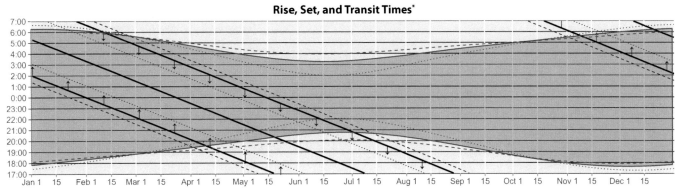

Rise, Set, and Transit Times*

* Rise/set times and total hours are based on the object being >15° above the horizon. Darkness defined as when the sun is >12° below horizon

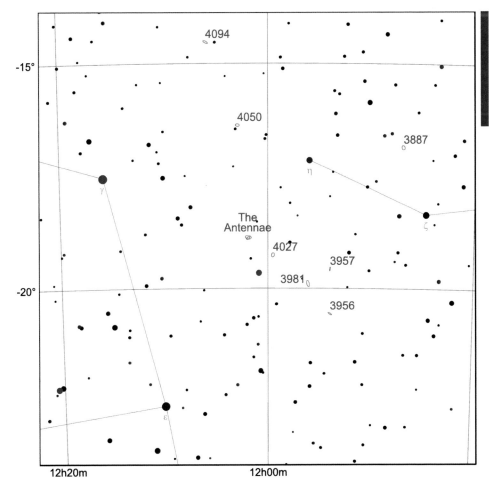

NGC4038 and NGC4039 form one of the most interesting interacting galaxy pairs in the sky. While each galaxy is small, they are bright, and the faint tidal tails span 20'. Push for long exposures to ensure the tidal tails are above the noise floor of your image.

M106

Type: Galaxy

Size: 19'×7'

Coordinates: 12h 18m, +47° 18'

Cataloged as: NGC4258

Quality imaging Hours*

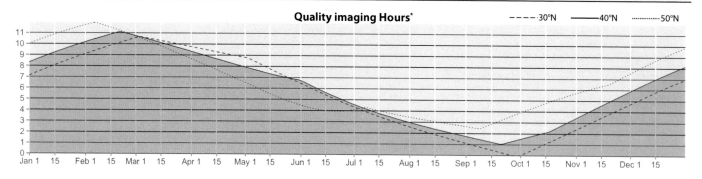

- - - - 30°N —— 40°N ····· 50°N

Rise, Set, and Transit Times*

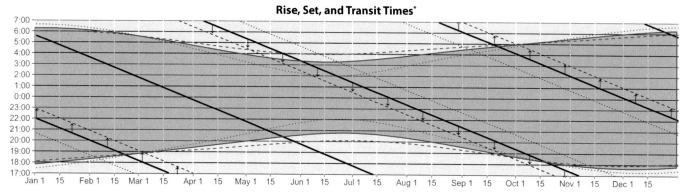

* Rise/set times and total hours are based on the object being >15° above the horizon. Darkness defined as when the sun is >12° below horizon

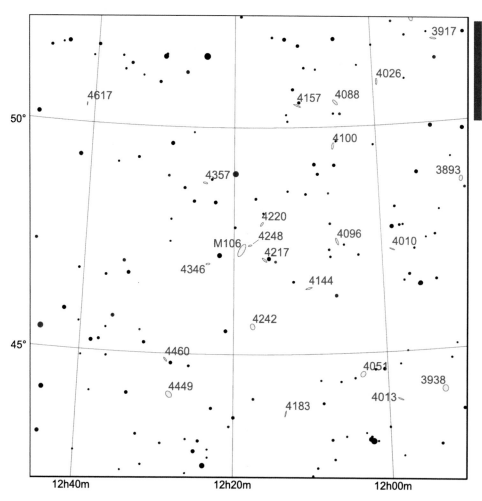

A fine spiral galaxy with fainter arms extending well beyond a bright, textured core. Its closest companion is NGC4248, but nearby NGC4231, 4232, 4217, and 4226 can also be captured in a 1 degree FOV.

Markarian's Chain

Type: Galaxy Group

Size: 1.5°×1.5°

Coordinates: 12h 26m, +12° 56'

Cataloged as: NGC4406

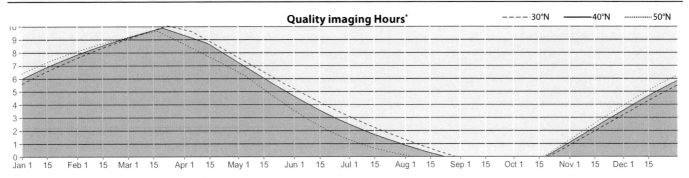

Quality imaging Hours*

- - - - 30°N ——— 40°N ·········· 50°N

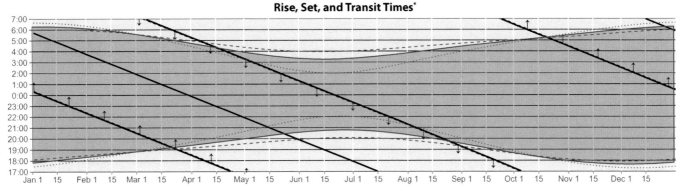

Rise, Set, and Transit Times*

* Rise/set times and total hours are based on the object being >15° above the horizon. Darkness defined as when the sun is >12° below horizon

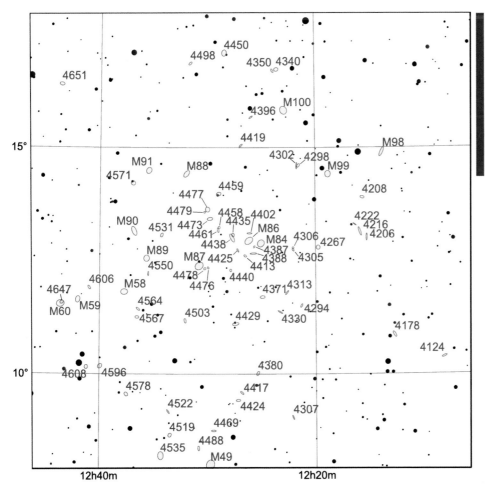

On their own, each of the galaxies in Markarian's Chain are mostly uninspiring ellipticals, but together, they are a cosmic panorama of the Virgo Cluster of galaxies. M84 and M86 are the bright galaxies than anchor the chain, but around 20 members are easily revealed, with deeper images showing dozens more in the background.

25

The Needle Galaxy (NGC4565)

Type: Galaxy
Size: 16'×2'

Coordinates: 12h 36m, +25° 59'
Cataloged as:

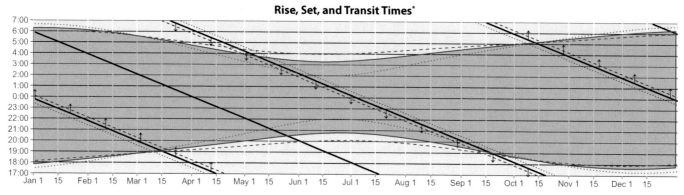

Quality imaging Hours*

Legend: - - - 30°N —— 40°N ········ 50°N

Rise, Set, and Transit Times*

* Rise/set times and total hours are based on the object being >15° above the horizon. Darkness defined as when the sun is >12° below horizon

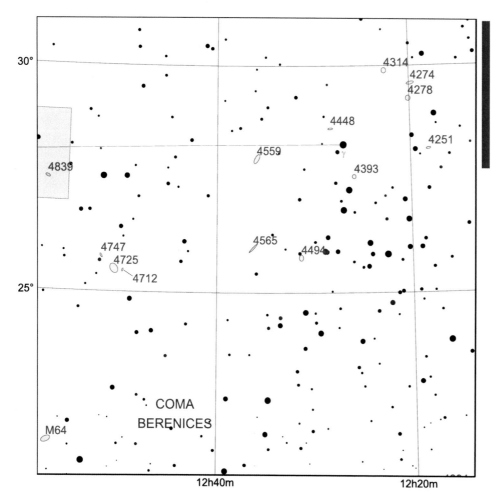

Its bulging core and dark dust lane make NGC4565 stand out from other edge-on galaxies. Due to its brightness, it's easy to capture, but it takes longer focal lengths and deconvolution processing to reveal tiny details in the central dust lane. The small companion 15' away is NGC4562, oriented perpendicularly to NGC4565.

The Sombrero Galaxy (M104)

Type: Galaxy

Size: 9'×4'

Coordinates: 12h 39m, -11° 37'

Cataloged as: M104, NGC4594

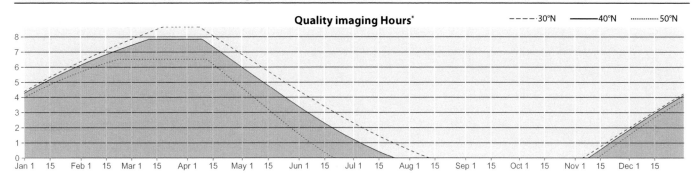

Quality imaging Hours*

- - - - 30°N —— 40°N ········· 50°N

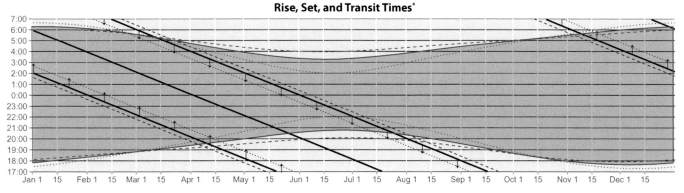

Rise, Set, and Transit Times*

* Rise/set times and total hours are based on the object being >15° above the horizon. Darkness defined as when the sun is >12° below horizon

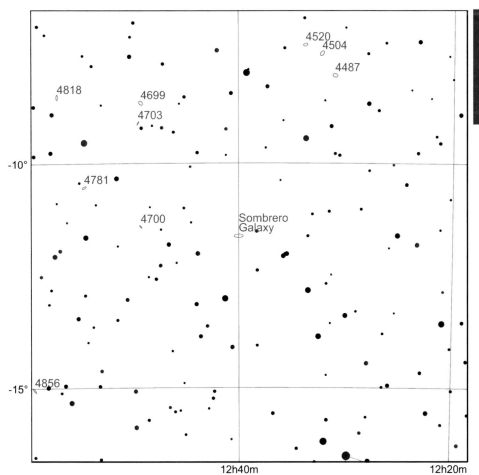

The Sombrero Galaxy is small but bright with a striking, thin dust lane. Speckled details can be resolved around the dust lane with careful processing. It was the first object to be included in Messier's catalog posthumously, as M104, in 1921.

The Whale and Hockey Stick Galaxies

Type: Galaxy Group
Size: 15'×3'

Coordinates: 12h 43m, +32° 20'
Cataloged as: NGC4531, NGC4656

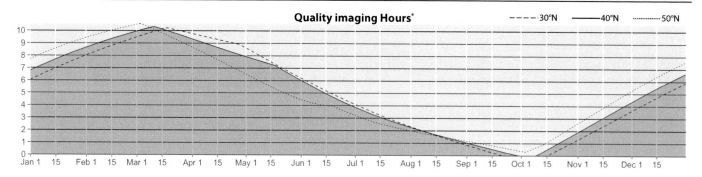

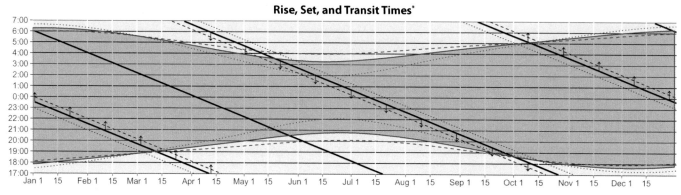

* Rise/set times and total hours are based on the object being >15° above the horizon. Darkness defined as when the sun is >12° below horizon

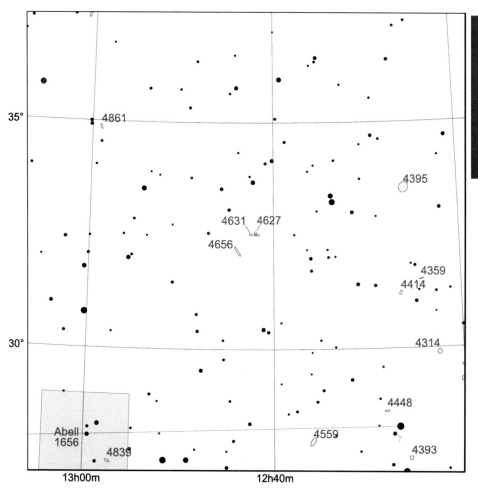

Two unique galaxies viewed edge-on, both about 15' across. The larger "Whale" (NGC4531) has a mottled dust and HII regions, and a satellite galaxy (its 'pup'?) NGC4627. A bit further away is the Hockey Stick Galaxy (NGC4656), with a strange L shape and extended gas trail that is likely from a past interaction with the Whale.

The Sunflower Galaxy (M63)

Type: Galaxy

Size: 13'×7'

Coordinates: 13h 15m, +42° 01'

Cataloged as: NGC5055

Quality imaging Hours*

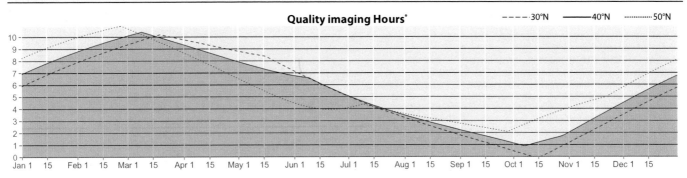

--- 30°N —— 40°N ·········· 50°N

Rise, Set, and Transit Times*

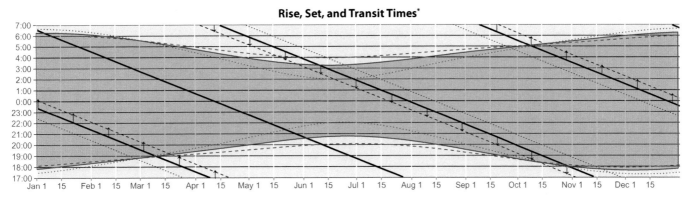

* Rise/set times and total hours are based on the object being >15° above the horizon. Darkness defined as when the sun is >12° below horizon

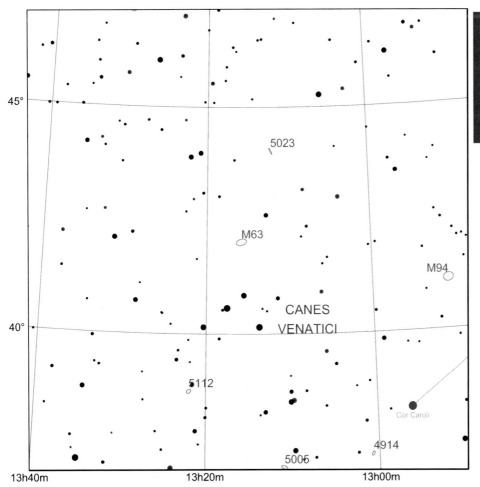

The Sunflower Galaxy has terrific flocculent details in its tightly-wound arms, with nice red-blue color contrast due to HII regions. There is a prominent dark dust lane that cuts across the front edge, and extremely deep images have revealed extended tidal tails surrounding it.

The Whirlpool Galaxy (M51)

Type: Galaxy

Size: 11'×8'

Coordinates: 13h 29m, +47° 11'

Cataloged as: NGC5194

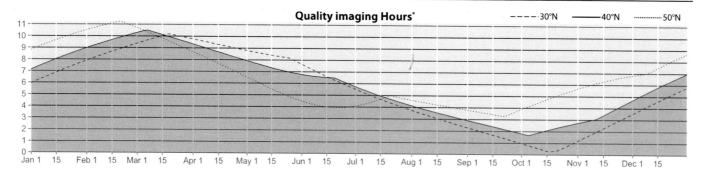

Quality imaging Hours*

––– 30°N ——— 40°N ·········· 50°N

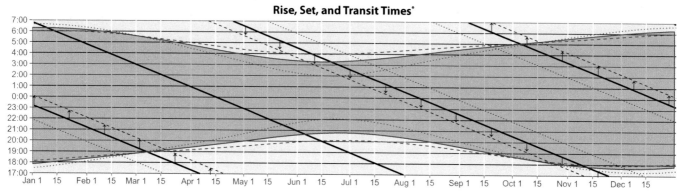

Rise, Set, and Transit Times*

* Rise/set times and total hours are based on the object being >15° above the horizon. Darkness defined as when the sun is >12° below horizon

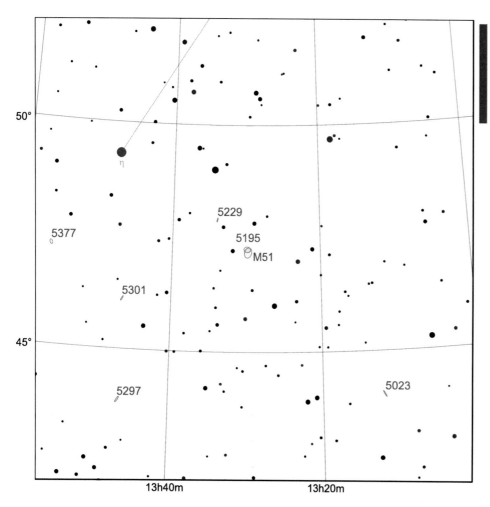

Worth imaging year after year due to its perfect spiral structure and color. Interaction with companion NGC5195 has created an enormous tidal tail that is visible with even moderate exposure time.

M3

Type: Globular Cluster **Coordinates:** 13h 42m, +28° 22'

Size: 18'×18' **Cataloged as:** NGC5272

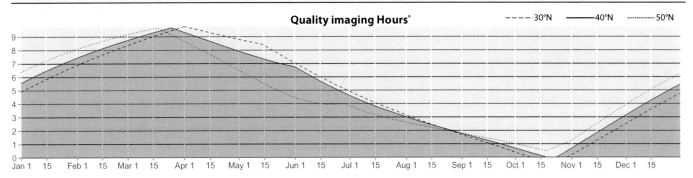

Quality imaging Hours* ---- 30°N —— 40°N ········ 50°N

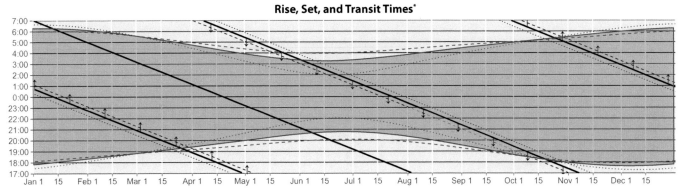

Rise, Set, and Transit Times*

* Rise/set times and total hours are based on the object being >15° above the horizon. Darkness defined as when the sun is >12° below horizon

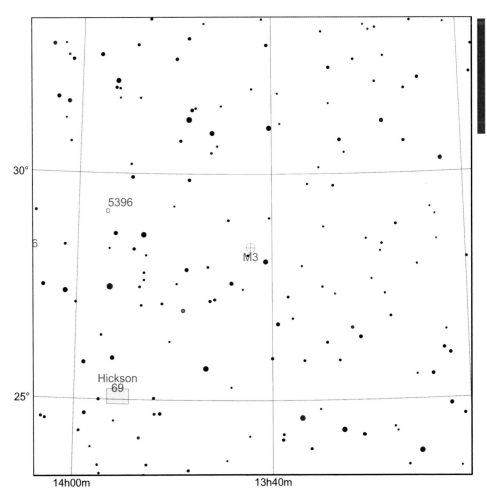

A dense, bright globular, and one of the best (along with M13 and M5) for northern hemisphere imagers. The first Messier object actually found by Messier; M1 and M2 were re-discoveries of objects previously noted by others.

31

The Pinwheel Galaxy (M101)

Type: Galaxy

Size: 29'×27'

Coordinates: 14h 03m, +54° 20'

Cataloged as: NGC5457

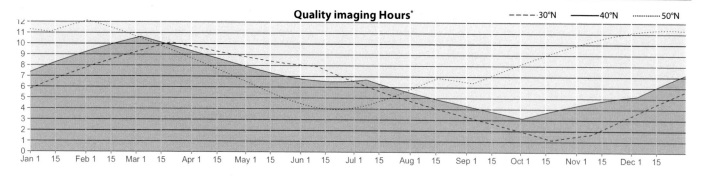

Quality imaging Hours*

– – – 30°N —— 40°N ······ 50°N

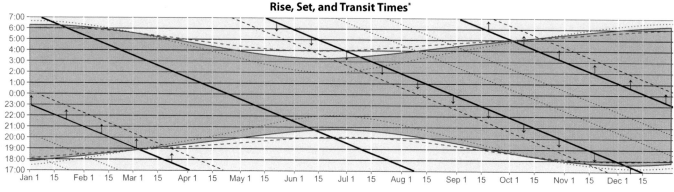

Rise, Set, and Transit Times*

* Rise/set times and total hours are based on the object being >15° above the horizon. Darkness defined as when the sun is >12° below horizon

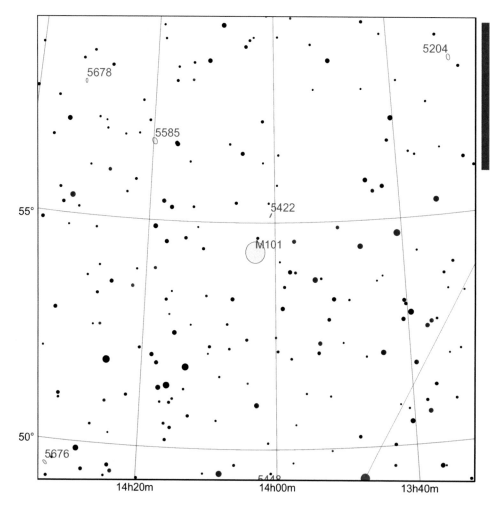

M101 is a very large, face-on galaxy with an asymmetrical spiral. It has numerous HII regions, but the overall surface brightness is low. Faint outer arms require careful processing. The several nearby companion galaxies are responsible for the asymmetry, with NGC5474 (a small face-on spiral) the most obviously visible in most images.

NGC5907

Type: Galaxy

Size: 13'×1'

Coordinates: 15h 15m, +56° 19'

Cataloged as:

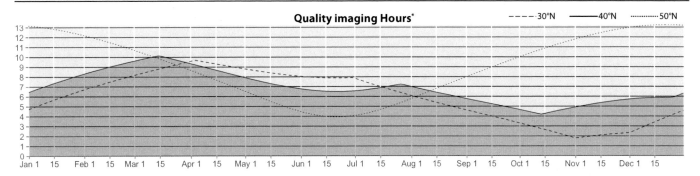

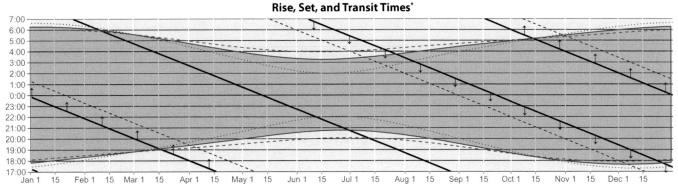

* Rise/set times and total hours are based on the object being >15° above the horizon. Darkness defined as when the sun is >12° below horizon

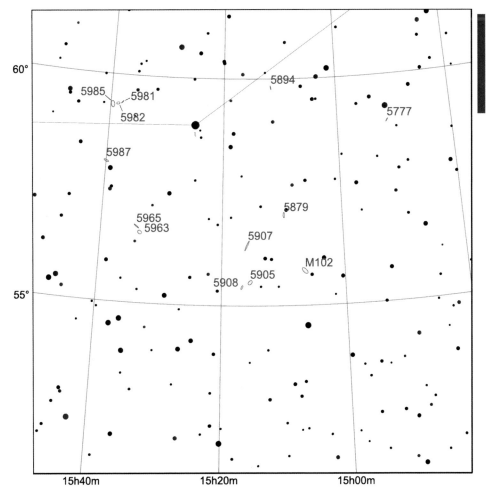

NGC 5907 is a thin, edge-on galaxy known as the Splinter Galaxy. Because of its high declination, it is a year-round target, but ideally image around May, when it spends the most time near the zenith.

M5

Type: Globular Cluster **Coordinates:** 15h 18m, +02° 04'

Size: 23'×23' **Cataloged as:** NGC5904

Quality imaging Hours*

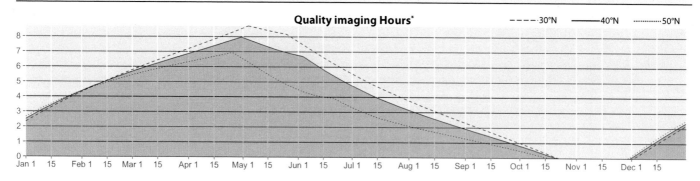

- - - 30°N —— 40°N ······ 50°N

Rise, Set, and Transit Times*

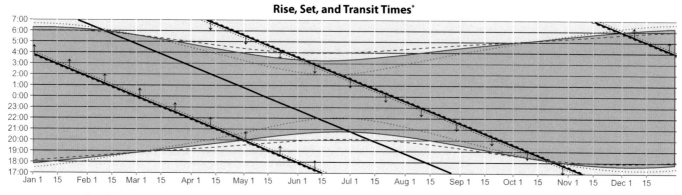

* Rise/set times and total hours are based on the object being >15° above the horizon. Darkness defined as when the sun is >12° below horizon

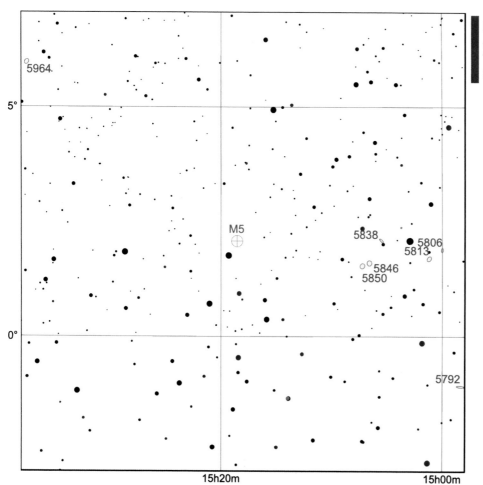

Bright, very dense. Processing can emphasize blue-gold contrast in stars. The nearby bright star is 5 Serpens (magnitude 5).

34

The Draco Trio

Type: Galaxy Group

Coordinates: 15h 39m, +59° 21'

Size: 50'×40'

Cataloged as:

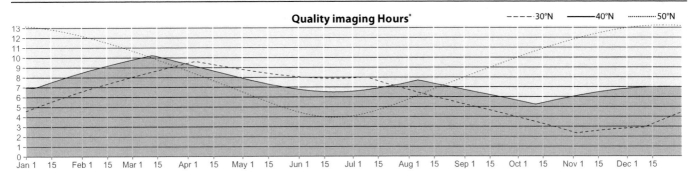

Quality imaging Hours*

- - - - 30°N ——— 40°N ·········· 50°N

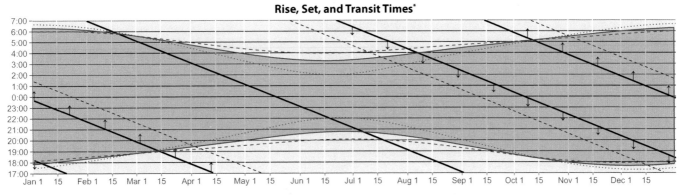

Rise, Set, and Transit Times*

* Rise/set times and total hours are based on the object being >15° above the horizon. Darkness defined as when the sun is >12° below horizon

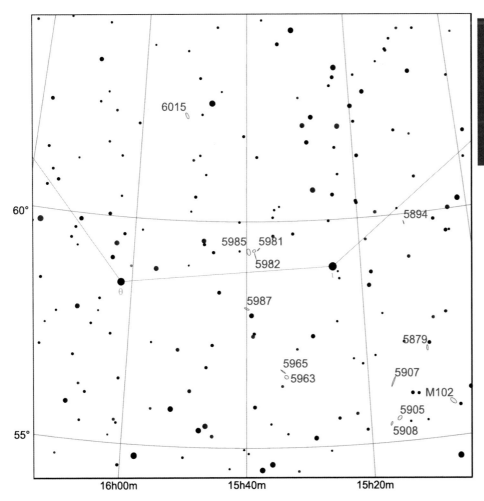

NGC 5981, 5982, and 5985 are lined up neatly in a row less than half a degree across, forming a trio of two spiral galaxies (one edge-on, one face-on) and an elliptical. This is a target for longer focal lengths, as each of the three galaxies is 5' or less across. Visible year-round, but best captured in May when it is highest in the sky.

35

The Rho Ophiuchi Area

Type: Reflection Nebula

Size: 1.8°×1.9°

Coordinates: 16h 29m, -25° 47'

Cataloged as: IC4606, vdB 107 (Antares Nebula); vdB 105 (IC4603); vdB 106 (IC4604); NGC6121 (M4)

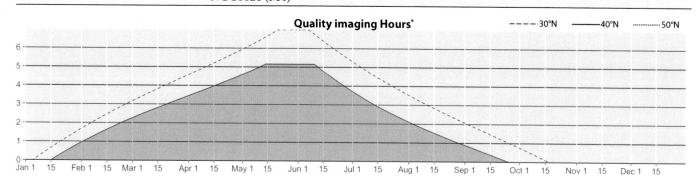

Quality imaging Hours*

- - - - 30°N ——— 40°N ········ 50°N

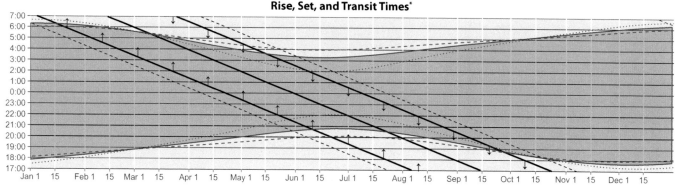

Rise, Set, and Transit Times*

* Rise/set times and total hours are based on the object being >15° above the horizon. Darkness defined as when the sun is >12° below horizon

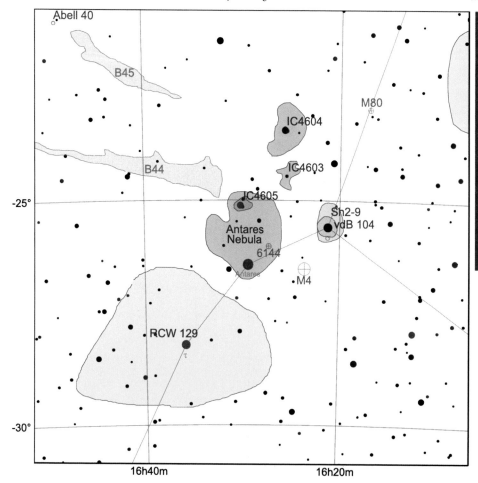

The most colorful area of the night sky. An amazing pentagon of objects: a dusty yellow reflection nebula (IC4606) encircles magnitude 1 Antares, with globular cluster M4 next door, a red emission nebula (Sh2-9) around magnitude 3 Alniyat, and two blue reflection nebulae (IC4603 and 4604) close out this group. Dark nebula Barnard 44 runs outward from the area. It's got everything but the kitchen sink. It requires a FOV of 3x4 degrees to capture it all, but even wider fields taken with telephoto lenses reveal the full extent of the dark nebula and nearby Milky Way.

The Great Hercules Cluster (M13)

Type: Globular Cluster **Coordinates:** 16h 41m, +36° 27'

Size: 20'×20' **Cataloged as:** NGC6205

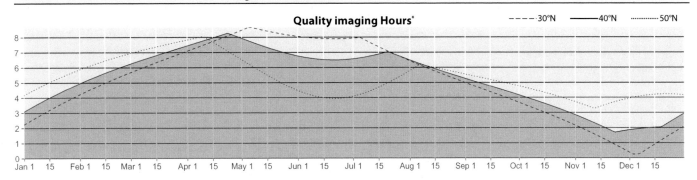

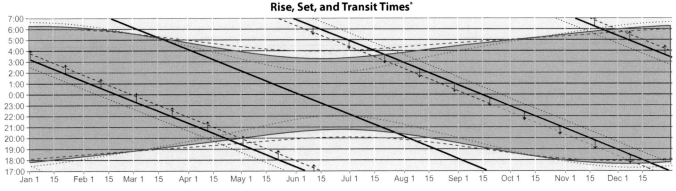

* Rise/set times and total hours are based on the object being >15° above the horizon. Darkness defined as when the sun is >12° below horizon

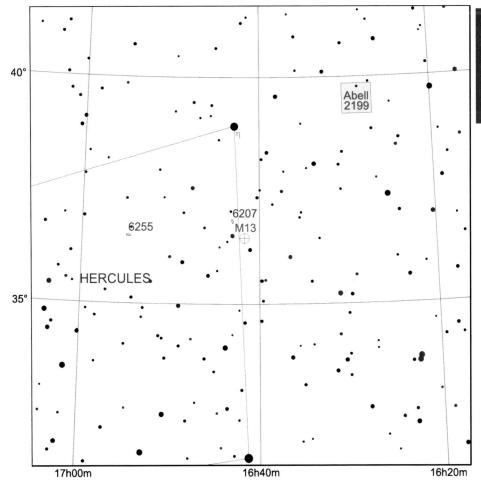

M13 is one of the finest, brightest globulars visible to those in the northern hemisphere. NGC6207, a 12th magnitude edge-on galaxy is 30' to the northeast, and deeper images may even capture IC4617 (mag 15) about 15' away in the same direction.

Type: Dark Nebula

Size: 30'×15' (Snake), 6.5°×3.1° (Pipe)

Coordinates: 17h 24m, -23° 36'

Cataloged as: B72 (Snake);

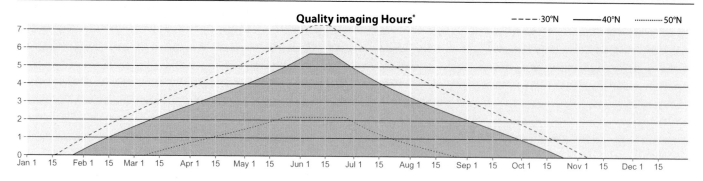

Quality imaging Hours*

– – – – 30°N ——— 40°N ·········· 50°N

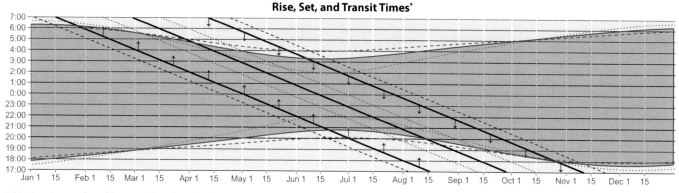

Rise, Set, and Transit Times*

* Rise/set times and total hours are based on the object being >15° above the horizon. Darkness defined as when the sun is >12° below horizon

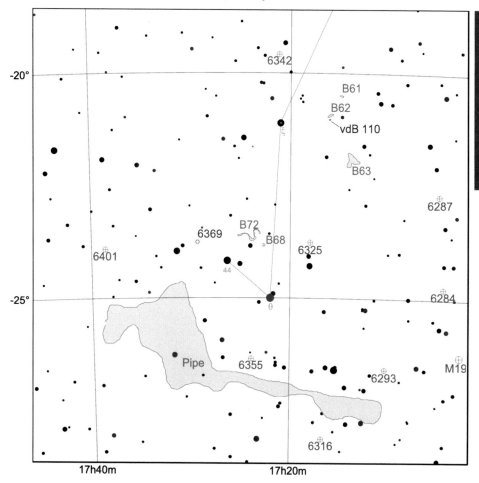

An object that really looks like its namesake, the Snake Nebula is a deep, S-shaped absence of stars in a dense area of the Milky Way. Nearby are smaller Barnard 69, 70, and 74. If it's not in your mount or software's catalog, look for nearby star 44 Ophiuchi (magnitude 4). Just south, the Pipe Nebula is a huge dark nebula that includes Barnard 59, 65, 66, 67, 77, 244, and 256.

The Trifid Nebula

Type: Emission Nebula

Size: 19'×21'

Coordinates: 18h 02m, -22° 58'

Cataloged as: M20, Sh2-30, NGC6514, RCW 147

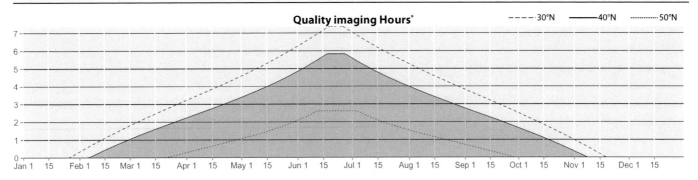

Quality imaging Hours*

- - - - 30°N — 40°N ·········· 50°N

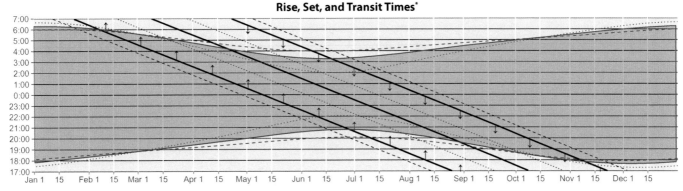

Rise, Set, and Transit Times*

* Rise/set times and total hours are based on the object being >15° above the horizon. Darkness defined as when the sun is >12° below horizon

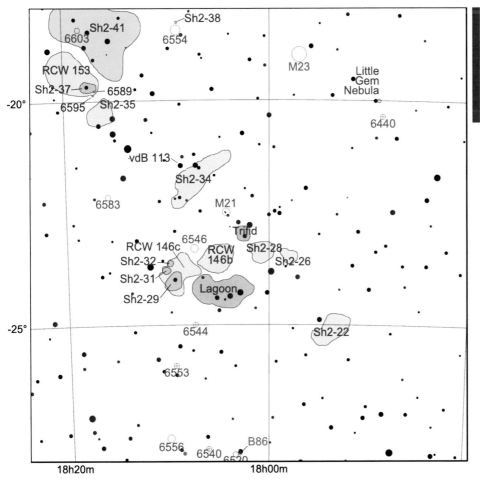

The Trifid is frequently imaged because of the spectacular red/blue contrast with dust lanes (B85) that divide it into at least three parts. Bold colors are revealed without narrowband filters. The blue portion is a reflection nebula, not due to OIII emission.

The Lagoon Nebula (M8)

Type: Emission Nebula

Size: 1.4°×0.8°

Coordinates: 18h 04m, -24° 15'

Cataloged as: M8, Sh2-25, NGC6533, RCW 146a, NGC6523, NGC6530

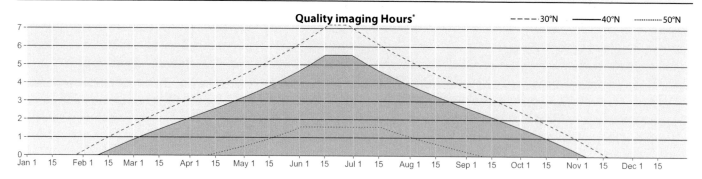

Quality imaging Hours* — — — 30°N ——— 40°N ········ 50°N

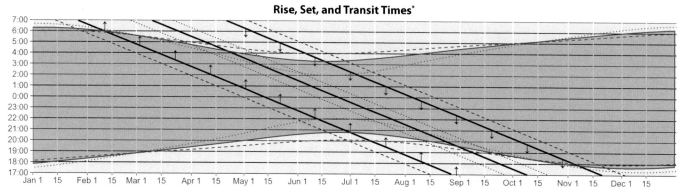

Rise, Set, and Transit Times*

* Rise/set times and total hours are based on the object being >15° above the horizon. Darkness defined as when the sun is >12° below horizon

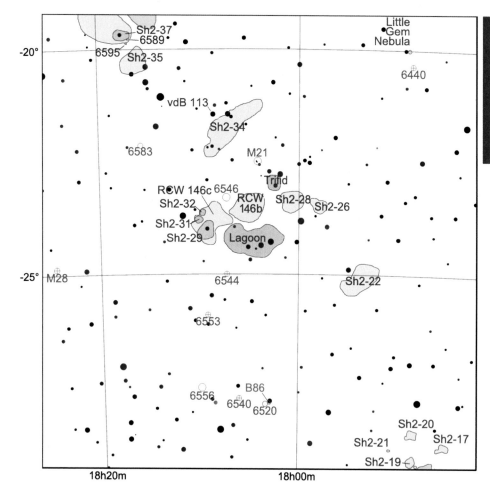

M8 is large and very bright, so bright that it can be seen with the naked eye. It looks great in RGB or narrowband. Even short exposures reveal wispy tendrils and dark globules, three of which are cataloged as Barnard 88 (on northern edge), 89 (west of center), and 296 (on southern edge). The central open cluster is NGC6530.

The Eagle and Swan Nebulae (M16 and M17)

Type: Emission Nebula

Coordinates: 18h 20m, -16° 05'

Size: 1.0°×0.7° (Swan); 1.2°×0.8° (Eagle)

Cataloged as: M17, Sh2-45, NGC6618, IC4706, IC4707, RCW 160 (Swan); M16, Sh2-49, NGC6611, IC4703, RCW 165 (Eagle)

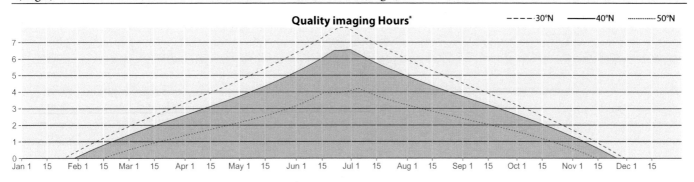

Quality imaging Hours*

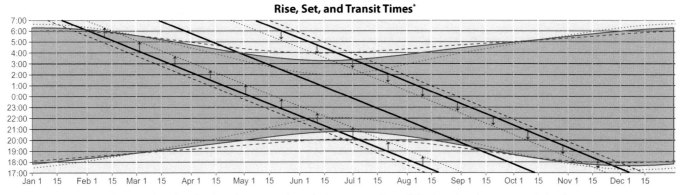

Rise, Set, and Transit Times*

* Rise/set times and total hours are based on the object being >15° above the horizon. Darkness defined as when the sun is >12° below horizon

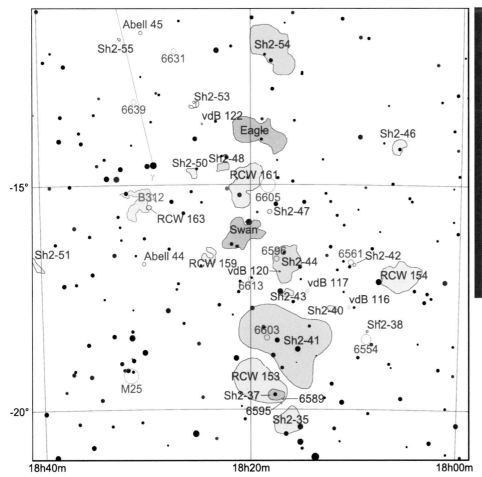

The Eagle Nebula is beautiful and bright, with H-alpha, OIII, SII. The famous Hubble image, "Pillars of Creation," is of the tendrils at its core. M16 is actually the central open cluster; the nebula is Sh2-49 or IC4703. The Swan (sometimes called Omega) nebula is a deep-sky highlight, though maybe not as photogenic as its neighbor. Very wide fields can capture both. H-alpha, SII, and OIII are all present. Almost connecting them is fainter RCW 161. Just north of the Eagle is often the larger, but often overlooked Sh2-54, which contains the large open cluster NGC6604 and a very bright knot that seems only to be cataloged by Gum as Gum 85.

M22

Type: Globular Cluster **Coordinates:** 18h 36m, -23° 54'

Size: 24'×24' **Cataloged as:** NGC6656

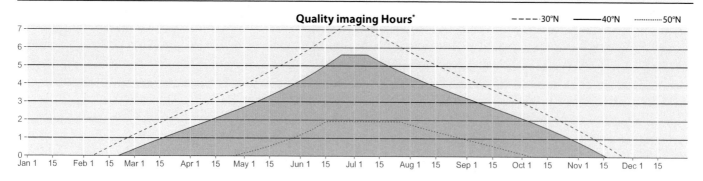

Quality imaging Hours*

Legend: - - - 30°N —— 40°N ······ 50°N

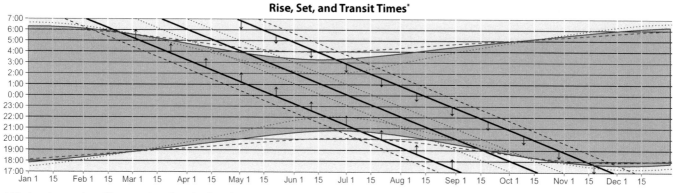

Rise, Set, and Transit Times*

* Rise/set times and total hours are based on the object being >15° above the horizon. Darkness defined as when the sun is >12° below horizon

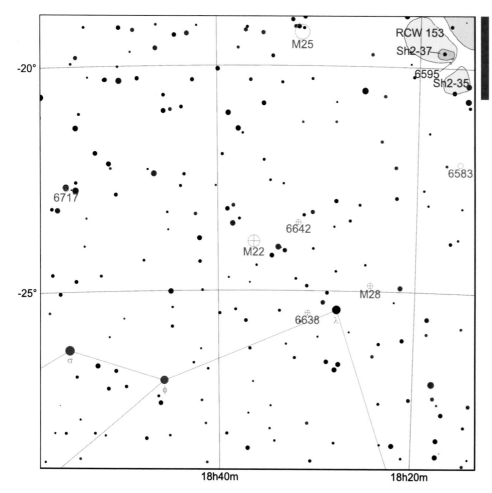

The brightest globular visible from the mid-northern latitudes. It's brighter than M13, but close to the horizon for most northern observers, making it a challenging target to capture clearly.

Barnard's E

Type: Dark Nebula **Coordinates:** 19h 40m, +10° 31'

Size: 40'×20' **Cataloged as:**

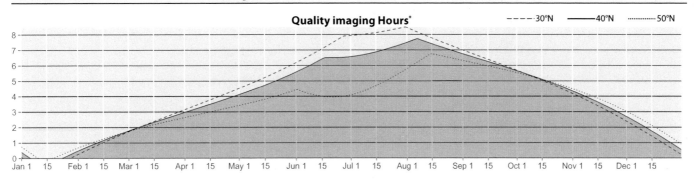

Quality imaging Hours*

— — — 30°N —— 40°N ········· 50°N

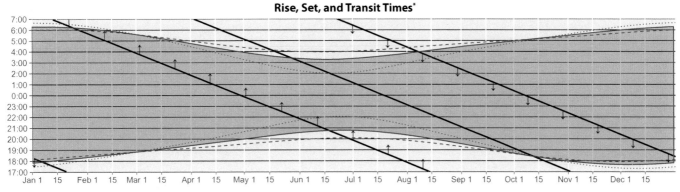

Rise, Set, and Transit Times*

* Rise/set times and total hours are based on the object being >15° above the horizon. Darkness defined as when the sun is >12° below horizon

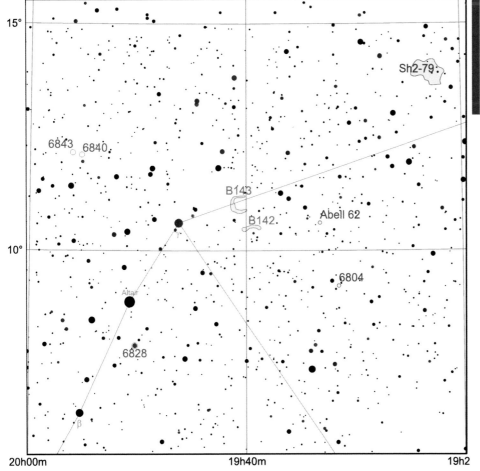

Barnard's E (B142 and B143) is one of the best dark nebulae in Barnard's catalog. Its outline against the dense Milky Way background is more like a C and a bar, but that doesn't have the same ring to it, so E it is. About 40' across.

Sh2-86

Type: Emission Nebula

Size: 30'×30'

Coordinates: 19h 43m, +23° 15'

Cataloged as: NGC6820

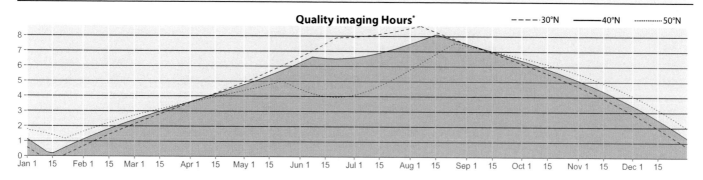

Quality imaging Hours*

--- 30°N —— 40°N ···· 50°N

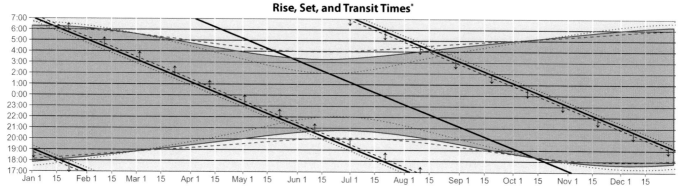

Rise, Set, and Transit Times*

* Rise/set times and total hours are based on the object being >15° above the horizon. Darkness defined as when the sun is >12° below horizon

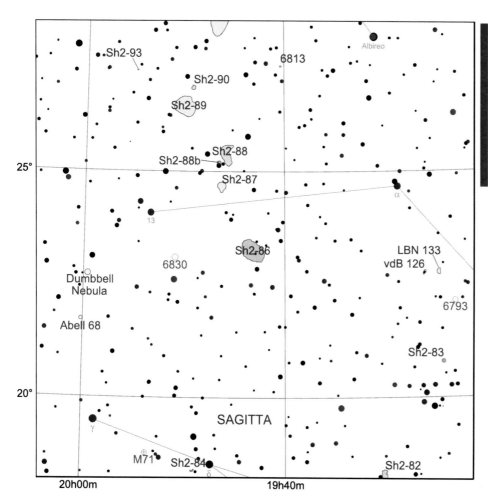

Sh2-86 is a bright emission nebula featuring a prominent central pillar. Great narrowband target, but allow plenty of exposure time for the SII and OIII channels to effectively capture the color variation. It contains open cluster NGC6823 and a tiny reflection nebula, NGC6820. Use either of these to locate it if it's not listed in your mount's database.

The Tulip Nebula (Sh2-101)

Type: Emission Nebula

Size: 14'×17'

Coordinates: 19h 59m, +35° 21'

Cataloged as: Sh2-101

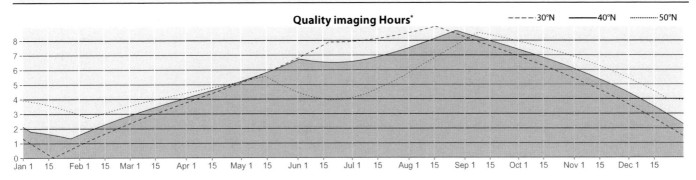

Quality imaging Hours*

--- 30°N —— 40°N ········ 50°N

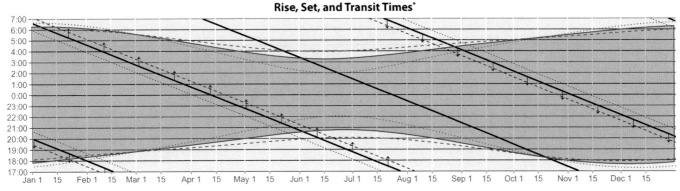

Rise, Set, and Transit Times*

* Rise/set times and total hours are based on the object being >15° above the horizon. Darkness defined as when the sun is >12° below horizon

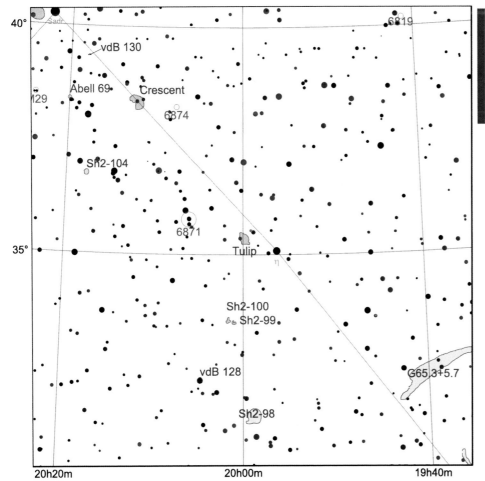

The Tulip Nebula (Sh2-101) in central Cygnus is a small emission nebula buried in the surrounding sea of nebulosity. Tighter FOVs reveal the dark tendrils on the southeast edge. It has fairly strong SII and OIII signals in its core.

The Dumbbell Nebula(M27)

Type: Planetary Nebula
Size: 8.0'×5.7'

Coordinates: 19h 59m, +22° 43'
Cataloged as: M27, NGC6853

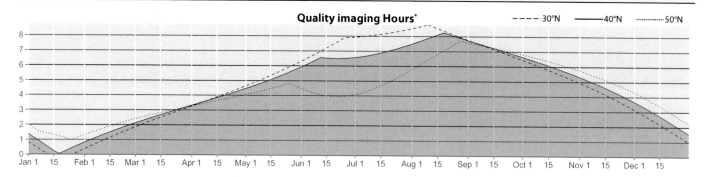

Quality imaging Hours*

– – – 30°N —— 40°N ········· 50°N

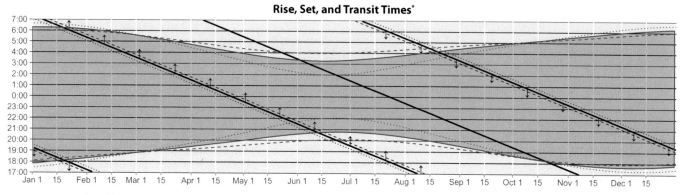

Rise, Set, and Transit Times*

* Rise/set times and total hours are based on the object being >15° above the horizon. Darkness defined as when the sun is >12° below horizon

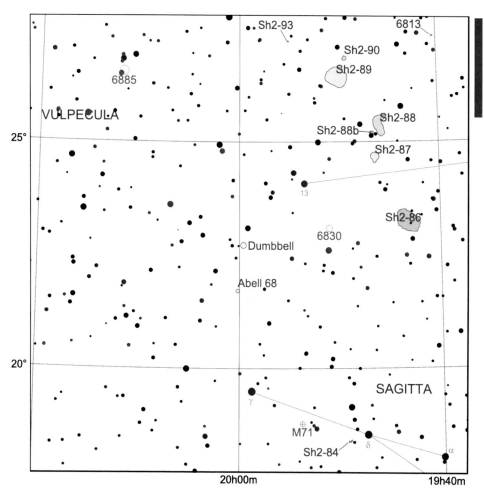

The Dumbbell nebula is bright and worthy of many images. RGB imaging works just fine here, though narrow-band filters will help with contrast. Emits in H-alpha, OIII, and SII, with a distinct NII emission.

The Crescent Nebula

Type: Emission Nebula

Size: 20'×19'

Coordinates: 20h 12m, +38° 20'

Cataloged as: Sh2-105, NGC6888

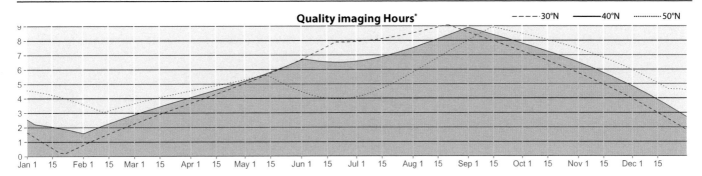

Quality imaging Hours* — 30°N, 40°N, 50°N

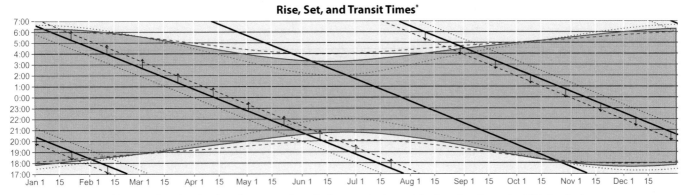

Rise, Set, and Transit Times*

* Rise/set times and total hours are based on the object being >15° above the horizon. Darkness defined as when the sun is >12° below horizon

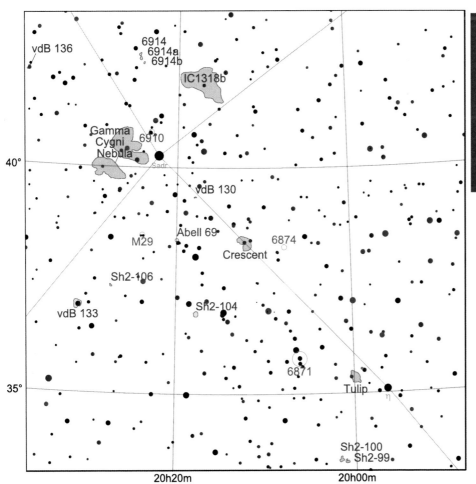

The Crescent Nebula (NGC6888) is bright, especially in H-alpha, but a beautiful OIII shell can also be revealed. Widefield images capture it within the surrounding sea of H-alpha, or even entire Sadr area. Try to find the nearby Soap Bubble Nebula (PN G75.5+1.7), discovered by amateur Dave Jurasevich in 2008. It can be easily lost in the background nebulosity, but it emits both Ha and OIII.

The Propeller Nebula

Type: Emission Nebula

Size: 12'×22'

Coordinates: 20h 16m, +43° 41'

Cataloged as: DWB111/118/119

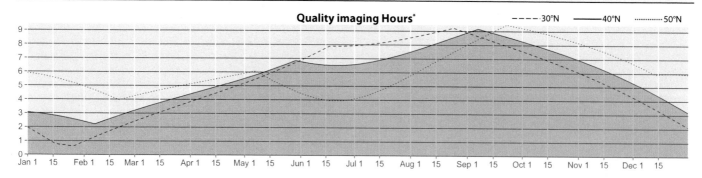

Quality imaging Hours*

— — 30°N —— 40°N ·········· 50°N

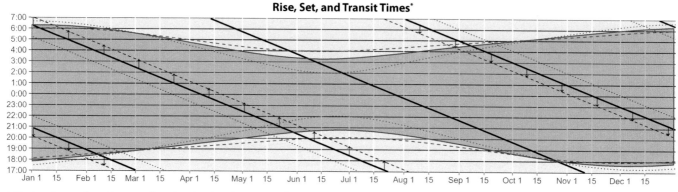

Rise, Set, and Transit Times*

* Rise/set times and total hours are based on the object being >15° above the horizon. Darkness defined as when the sun is >12° below horizon

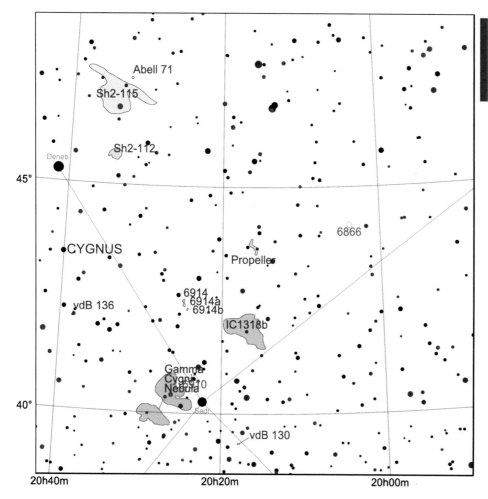

Not often imaged, the Propeller (DWB111) is a distinct 'S' or propeller shape within Cygnus's sea of nebulosity. Narrowband filters provide the best contrast to bring out its structure.

The Gamma Cygni (Sadr) Nebula

Type: Emission Nebula

Size: 1.3°×1.2°

Coordinates: 20h 26m, +40° 17'

Cataloged as: Sh2-108, IC1318

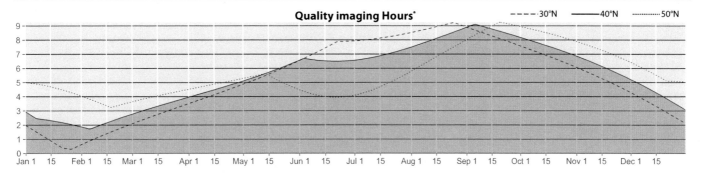

Quality imaging Hours*

- - - 30°N ——— 40°N ········· 50°N

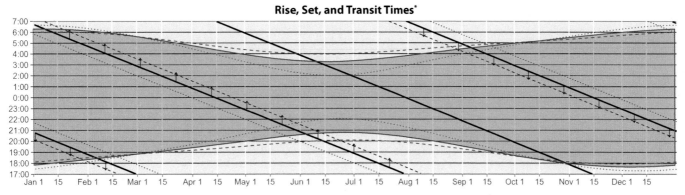

Rise, Set, and Transit Times*

* Rise/set times and total hours are based on the object being >15° above the horizon. Darkness defined as when the sun is >12° below horizon

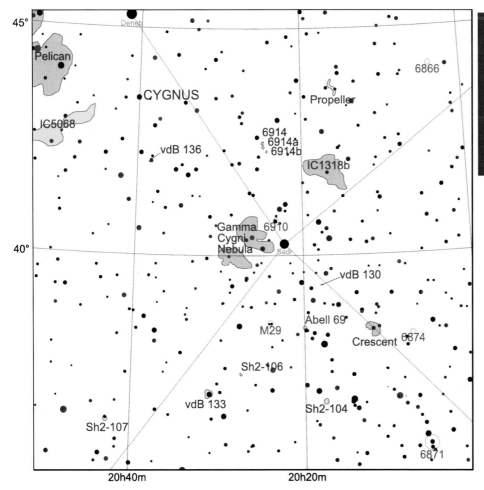

Sometimes called the Butterfly Nebula, this large emission nebula surrounds the magnitude 2 star Sadr (Gamma Cygni). Similar to most emission nebulae, it is bright in H-alpha with dimmer SII and OIII signals. The surrounding area is so saturated with nebulosity that very wide (5-10 degree) FOVs are feasible to show the object in context.

The Fireworks Galaxy (NGC6946)

Type: Galaxy

Size: 12'×10'

Coordinates: 20h 34m, +60° 09'

Cataloged as: Arp 29

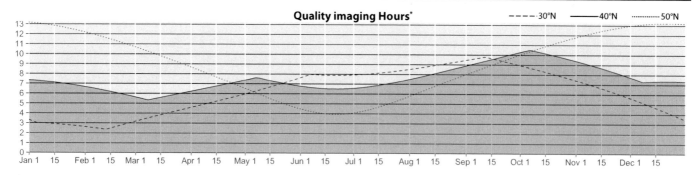

Quality imaging Hours*

---- 30°N —— 40°N ······ 50°N

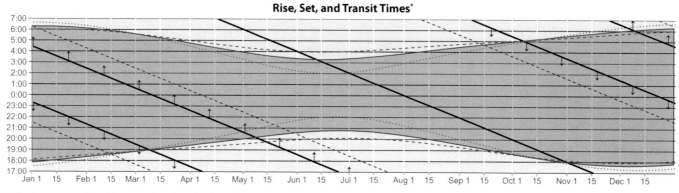

Rise, Set, and Transit Times*

* Rise/set times and total hours are based on the object being >15° above the horizon. Darkness defined as when the sun is >12° below horizon

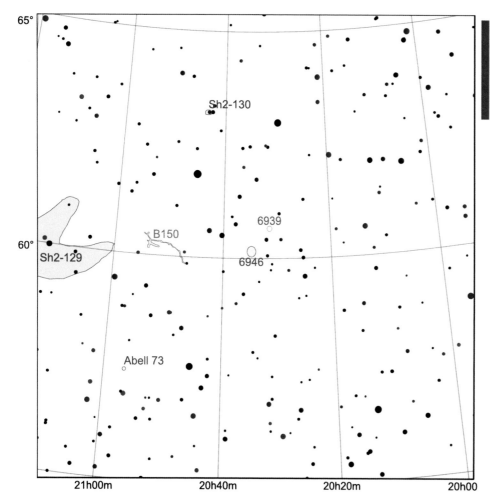

A very nice face-on galaxy. Near open cluster NGC6939, which can make an interesting pairing. Ideally imaged in August when it spends the most time near the zenith, but it can be imaged nearly any time of year.

The Cygnus Veils

Type: Emission Nebula

Coordinates: 20h 46m, +30° 37'

Size: 0.5°×1.1°

Cataloged as: NGC6960, Witch's Broom (Western Veil); Sh2-103, NGC6992, NGC6995 (Eastern Veil); NGC6979 (Pickering's Triangle)

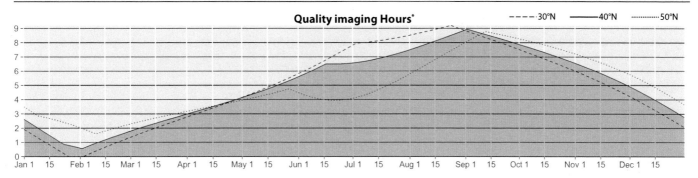

Quality imaging Hours*

– – – 30°N ——— 40°N ·········· 50°N

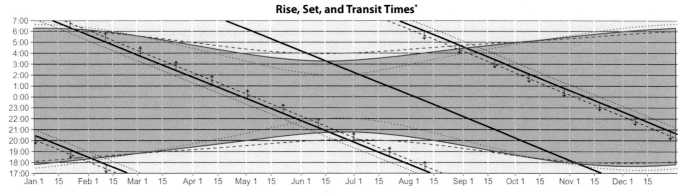

Rise, Set, and Transit Times*

* Rise/set times and total hours are based on the object being >15° above the horizon. Darkness defined as when the sun is >12° below horizon

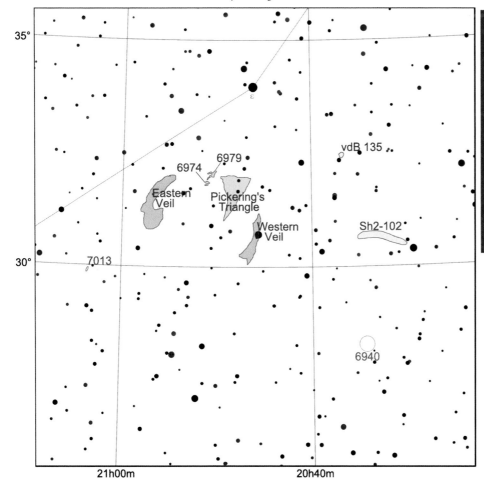

The wispy Veils of Cygnus are an imager's dream: bright, wispy tendrils everywhere, with bold colors revealed by both RGB and narrowband. The Western Veil is sometimes called the Witch's Broom. It has bright red and blue tendrils around star 52 Cygni, which can require careful processing to prevent the halo from obscuring the nebulosity around it. The Eastern Veil also has prominent red and blue contrasting structures as well. Pickering's Triangle sits between the two veils, and while dimmer, it is beautiful in its own right.

The North America and Pelican Nebulae

Type: Emission Nebula

Coordinates: 20h 59m, +44° 28'

Size: 2.5°×3.3°

Cataloged as: Sh2-117, NGC7000 (North America); IC5070 (Pelican)

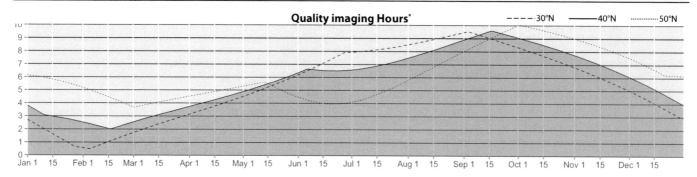

Quality imaging Hours* ----30°N ——40°N 50°N

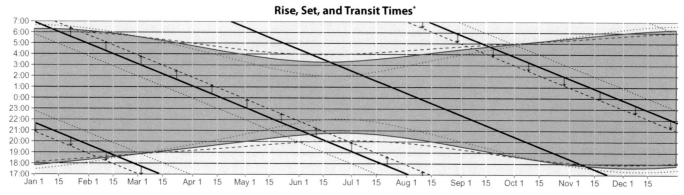

Rise, Set, and Transit Times*

* Rise/set times and total hours are based on the object being >15° above the horizon. Darkness defined as when the sun is >12° below horizon

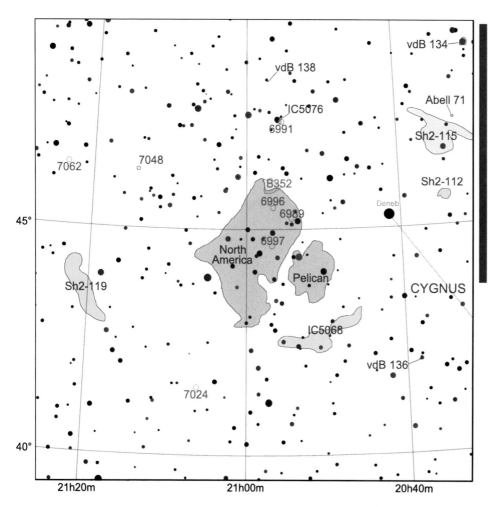

The North America Nebula (NGC7000) region is a huge (2.5°×3.3°), spectacular emission nebula, often imaged with the connected Pelican Nebula. They are separated by the dark nebula LDN935. The area corresponding to southern Mexico is known as the Great Wall, and it's a great target within the overall complex for narrower FOVs. Ha, SII, and OIII abundant throughout, though Ha far brighter, as with any emission nebula. To avoid a cliched image, consider framing or rotating your image to force an interpretation other than the usual.

The Iris Nebula

Type: Reflection Nebula **Coordinates:** 21h 01m, +68° 09'

Size: 11'×11' **Cataloged as:** NGC7023, vdB 139

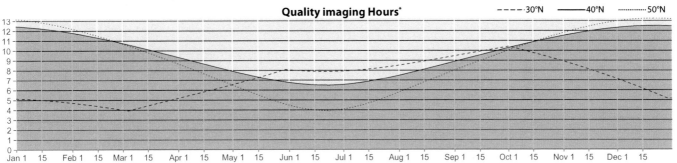

Quality imaging Hours* - - - - 30°N —— 40°N ········ 50°N

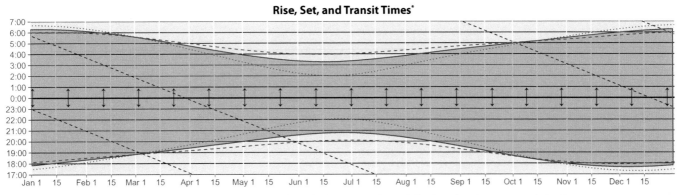

Rise, Set, and Transit Times*

* Rise/set times and total hours are based on the object being >15° above the horizon. Darkness defined as when the sun is >12° below horizon

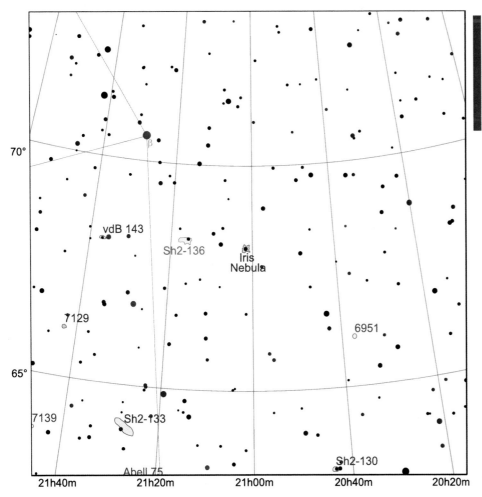

Beautiful RGB target. While the visible part of the blue reflection nebula is only about 8' across, the surrounding folds of dust (dark nebulae LDN 1170-74) span several degrees. Dust can be challenging to process in light polluted skies.

53

Type: Emission Nebula

Size: 2.3°×1.9°

Coordinates: 21h 09m, +60° 08'

Cataloged as:

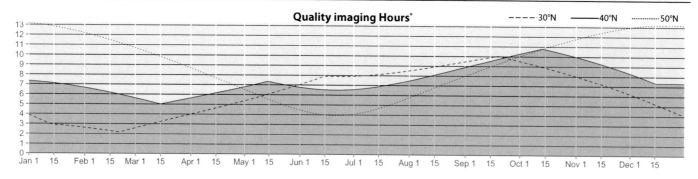

Quality imaging Hours*

------ 30°N —— 40°N ········· 50°N

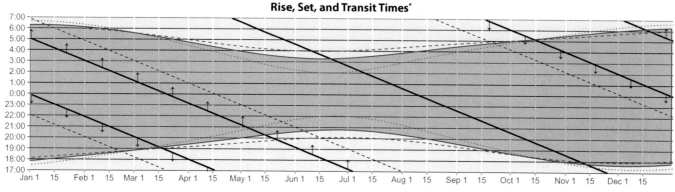

Rise, Set, and Transit Times*

* Rise/set times and total hours are based on the object being >15° above the horizon. Darkness defined as when the sun is >12° below horizon

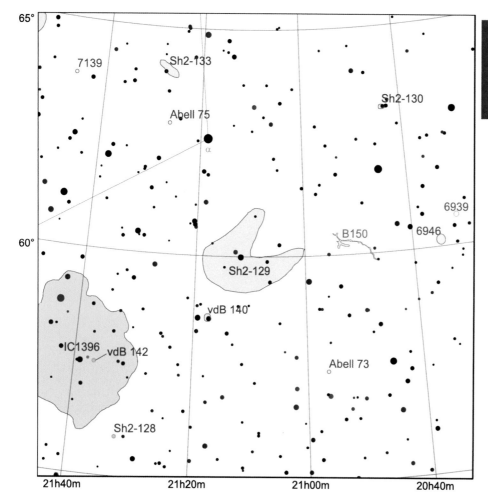

Sometimes called the Flying Bat Nebula, Sh2-249 is a photogenic object in H-alpha. Extremely long OIII exposures may reveal faint planetary OU4 in the middle, though this is a notoriously difficult challenge.

The Elephant's Trunk (IC1396)

Type: Emission Nebula **Coordinates:** 21h 38m, +57° 40'

Size: 2.6°×3.4° **Cataloged as:** Sh2-131

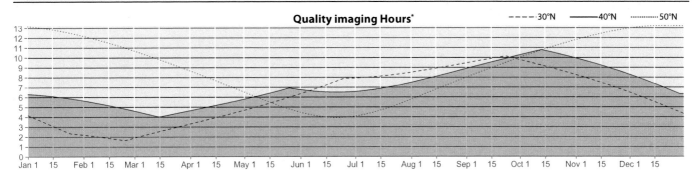

Quality imaging Hours*

- - - - 30°N —— 40°N ·········· 50°N

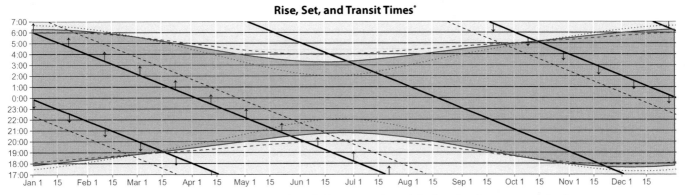

Rise, Set, and Transit Times*

* Rise/set times and total hours are based on the object being >15° above the horizon. Darkness defined as when the sun is >12° below horizon

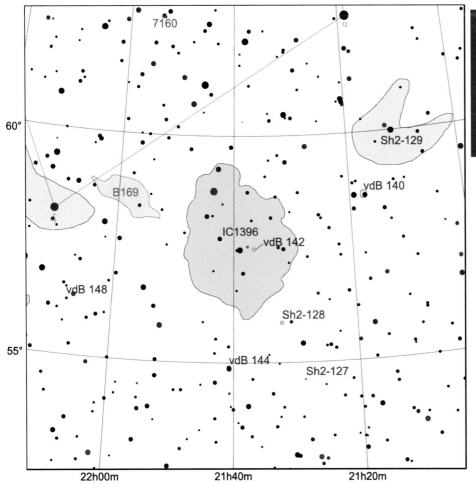

A huge round emission nebula known for the "Elephant Trunk" structure that appears to unfurl right into the center. Clear signal in H-alpha, SII, and OIII. North side features Mu Cephei, the Garnet Star. IC1396 is technically the embedded open cluster. Multiple dark nebulae/Bok globules within.

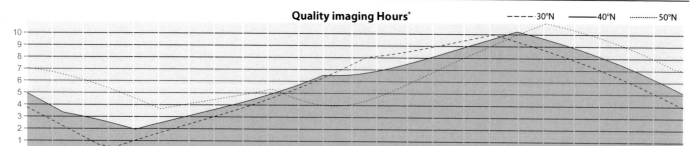

The Cocoon Nebula

Type: Emission Nebula

Size: 11'×12'

Coordinates: 21h 53m, +47° 15'

Cataloged as: Sh2-125, IC5146

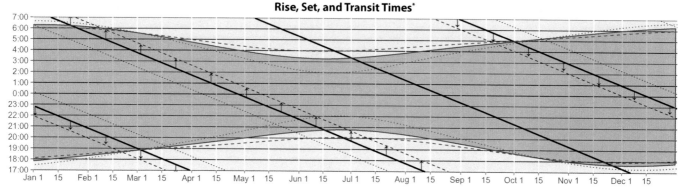

Quality imaging Hours*

- - - - 30°N —— 40°N ·········· 50°N

Rise, Set, and Transit Times*

* Rise/set times and total hours are based on the object being >15° above the horizon. Darkness defined as when the sun is >12° below horizon

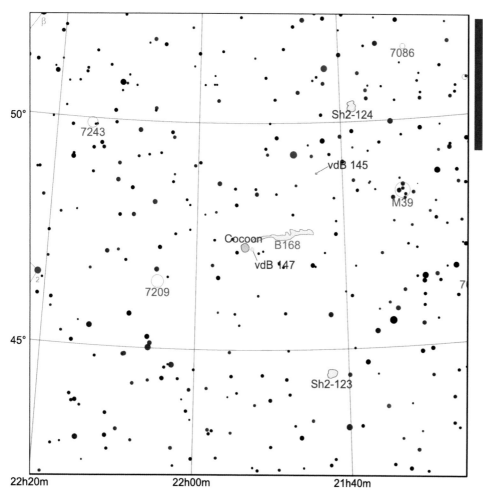

Small, but often imaged for good reason. Emission and reflection components with a dark nebula (B168) that streaks away westward across the dense background of Milky Way stars. Framed well both in close-up and widefield. No significant OIII emission.

The Wolf's Cave (vdB 152 and B175)

Type: Dark and Ref Neb
Coordinates: 22h 13m, +70° 40'

Size: 15'×50'
Cataloged as: Ced 201 (vdB 152)

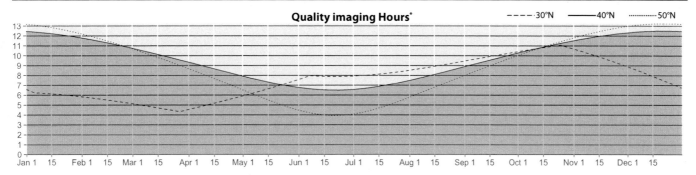

Quality imaging Hours*

‒ ‒ ‒ 30°N　——— 40°N　········ 50°N

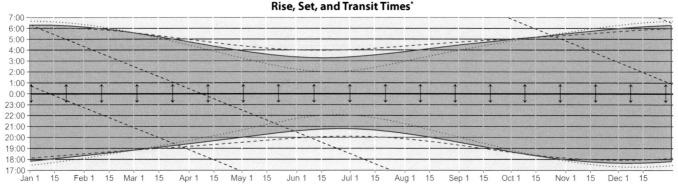

Rise, Set, and Transit Times*

* Rise/set times and total hours are based on the object being >15° above the horizon. Darkness defined as when the sun is >12° below horizon

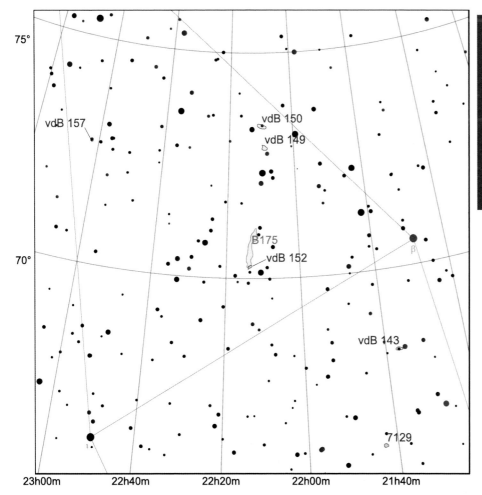

Barnard 175 in Cepheus is a long dark nebula with the small (5') blue reflection nebula vdB 152 at one end. The complex is referred to as Wolf's Cave (after astronomer Max Wolf). There is a small emission nebula, LBN 538, nearby. At 70°N, these objects are nearly circumpolar, but more southerly imagers may want to capture them in September, when they spend most of the night highest in the sky, above the celestial pole.

Sh2-132

Type: Emission Nebula

Coordinates: 22h 17m, +55° 59'

Size: 1.2°×0.9°

Cataloged as:

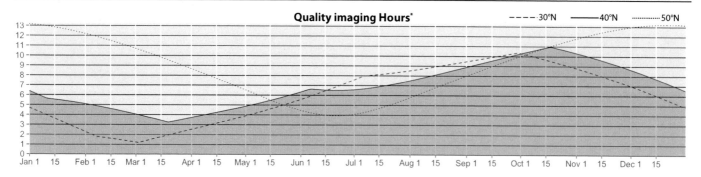

Quality imaging Hours*

- - - - 30°N —— 40°N ········ 50°N

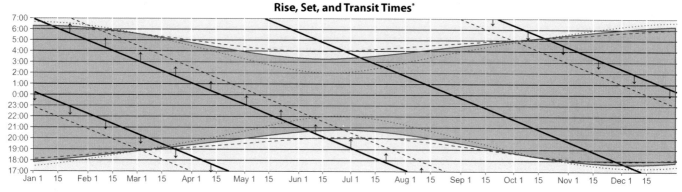

Rise, Set, and Transit Times*

* Rise/set times and total hours are based on the object being >15° above the horizon. Darkness defined as when the sun is >12° below horizon

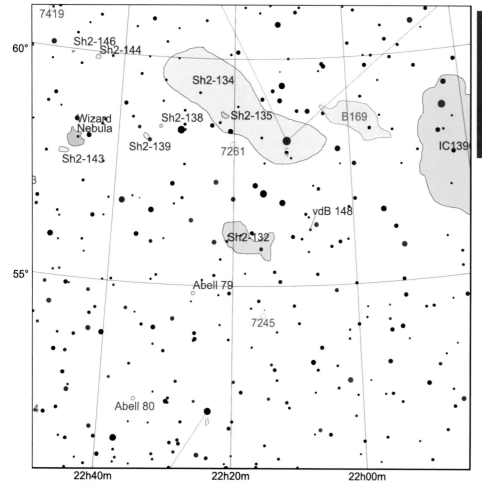

Looking like a lion when oriented the right way, Sh2-132 is a narrowband target with prominent OIII in the "body" and H-alpha and SII that form a wrinkly "head." Very large and faint, this object is a great example of how electronic imaging allows us to reveal beauty in objects that were hitherto ignored.

The Helix Nebula

Type: Planetary Nebula
Size: 18'×18'

Coordinates: 22h 29m, -20° 50'
Cataloged as: NGC7293

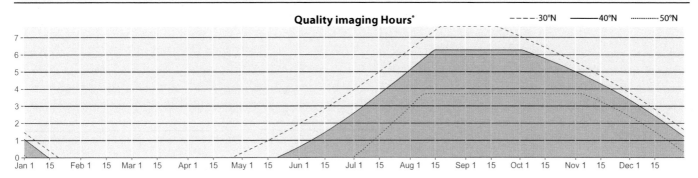

Quality imaging Hours*

--- 30°N ——— 40°N ········· 50°N

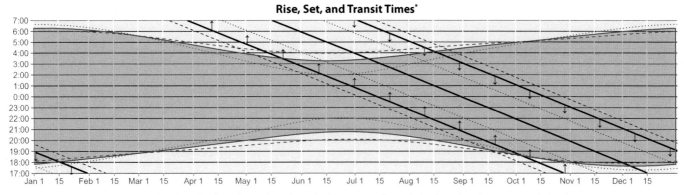

Rise, Set, and Transit Times*

* Rise/set times and total hours are based on the object being >15° above the horizon. Darkness defined as when the sun is >12° below horizon

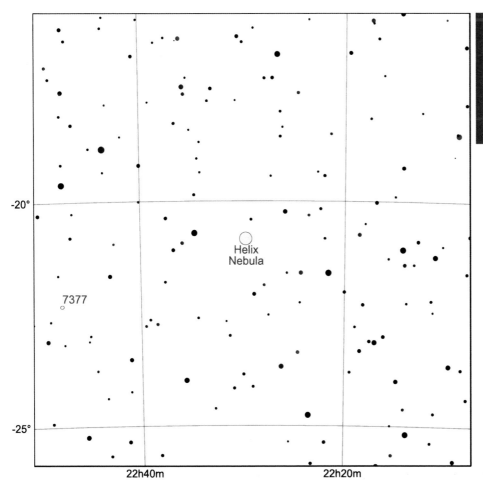

The Helix Nebula is the largest of the bright planetary nebulae, and possibly the finest. It has an iconic "eye" shape with blue in the center that shifts to bold reds around the rim. Narrow-band filters are not needed to reveal the colors, but they will help with contrast.

Type: Galaxy Group **Coordinates:** 22h 35m, +33° 57'

Size: 5'×3' **Cataloged as:** Hickson 92

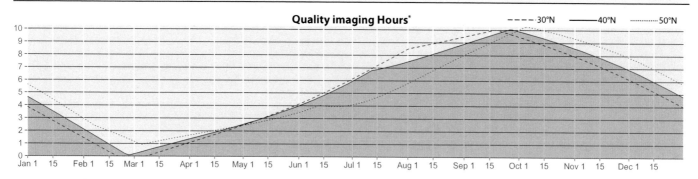

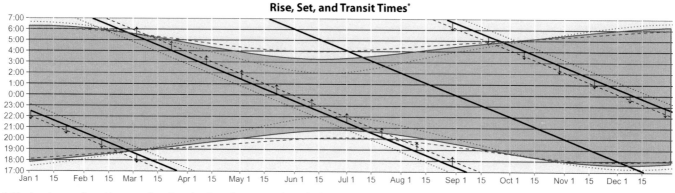

* Rise/set times and total hours are based on the object being >15° above the horizon. Darkness defined as when the sun is >12° below horizon

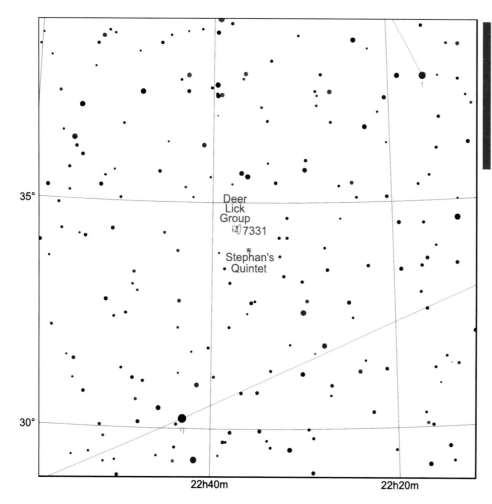

NGC7331 is a beautiful spiral on its own, but even more impressive as the largest (11'×4') member of the Deer Lick Group with much smaller NGC 7335, 7336, 7337, and 7340. Only 30' away is Stephan's Quintet, a tight grouping of galaxies for very long focal lengths that includes NGC 7317, 7318A/B, 7319, and 7320.

The Wizard Nebula (NGC7380)

Type: Emission Nebula

Size: 24'×26'

Coordinates: 22h 47m, +58° 04'

Cataloged as: Sh2-142, NGC7380

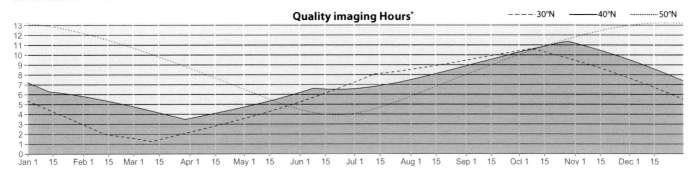

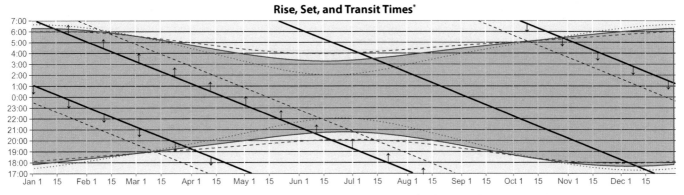

*Rise/set times and total hours are based on the object being >15° above the horizon. Darkness defined as when the sun is >12° below horizon

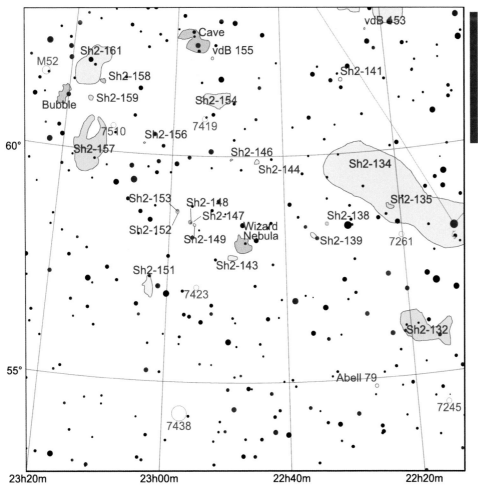

While you have to squint to see a wizard here, the dust and protrusions make this a visually stunning object. Terrific in mapped-color images, it has distinct areas of H-alpha, SII, and OIII. Contains open cluster NGC7380. The dimmer nebula 20' south is Sh2-143.

The Bubble and the Lobster Claw

Type: Emission Nebula **Coordinates:** 23h 20m, +61° 09'

Size: 18'×27' **Cataloged as:** Sh2-162, NGC7635 (The Bubble Nebula)

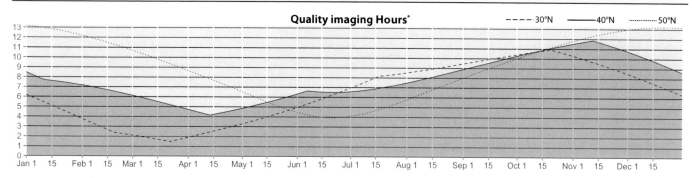

Quality imaging Hours*

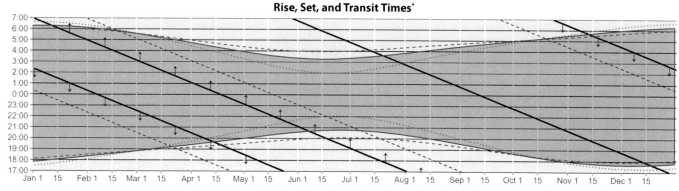

Rise, Set, and Transit Times*

* Rise/set times and total hours are based on the object being >15° above the horizon. Darkness defined as when the sun is >12° below horizon

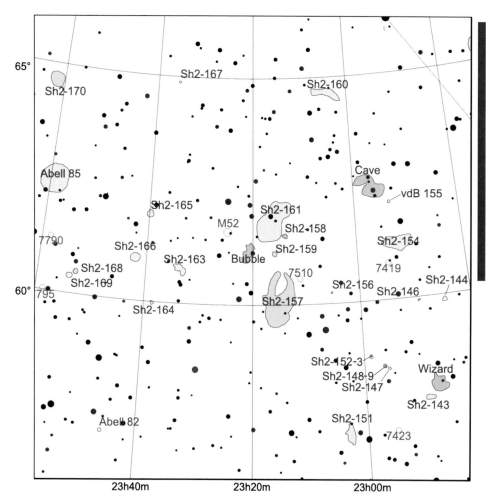

Sh2-157 really does look like a lobster claw, but its lack of clearly contrasting structures or details can make it an underwhelming target. There is solid OIII signal in the two pinchers, and SII in the base. Sh2-162 is probably more photogenic: a bright emission nebula with a distinct bubble at its core. It's close to cluster M52, and all three objects can be captured in the same image. Nearby Sh2-158, 159, and 161 can be included in a frame 3 degrees across. This whole area is a classic autumn target, with many objects available to combine in widefield shots.

Ced214 and Sh2-171

Type: Emission Nebula

Size: 2.1°×1.8°

Coordinates: 23h 59m, +67° 59'

Cataloged as: NGC7822, Ced 215 (Sh2-171)

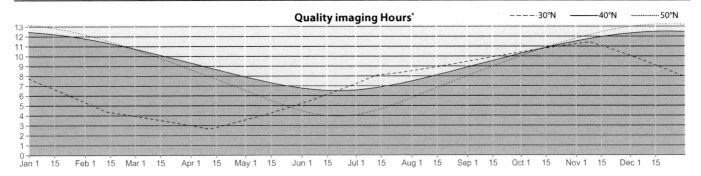

Quality imaging Hours* — — 30°N —— 40°N ···· 50°N

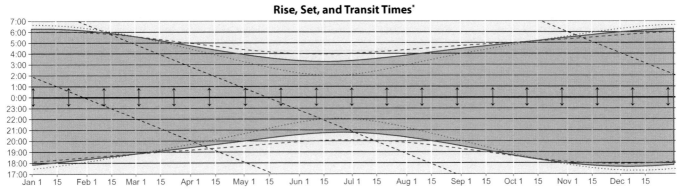

Rise, Set, and Transit Times*

* Rise/set times and total hours are based on the object being >15° above the horizon. Darkness defined as when the sun is >12° below horizon

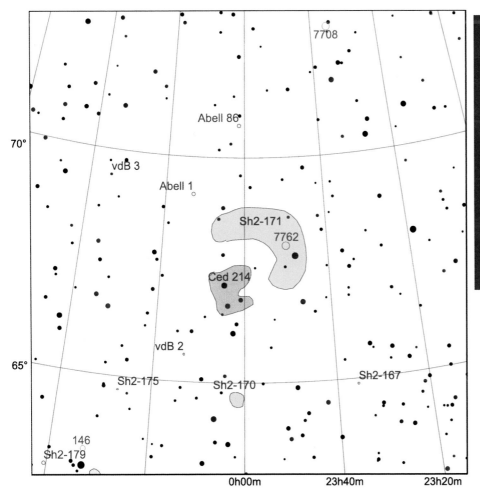

Ced214 and Sh2-171 (aka Ced 215) are great narrowband targets, and very wide fields reveal them together as a sort of question mark shape (see the front cover). The whole nebulosity that forms the top of the question mark is cataloged as Sh2-171. The bright part in the middle is specifically cataloged as Ced 214. The 'dot' of the question mark is Sh2-170. The small cluster just outside of Sh2-171 is known as King 11. The larger cluster in the same area, but just inside the nebulosity is NGC7762. These can be imaged nearly year-round, but early fall has them best positioned high in the sky.

The Andromeda Galaxy (M31)

Type: Galaxy

Size: 3.2°×1.0°

Coordinates: 00h 42m, +41° 16'

Cataloged as: NGC224

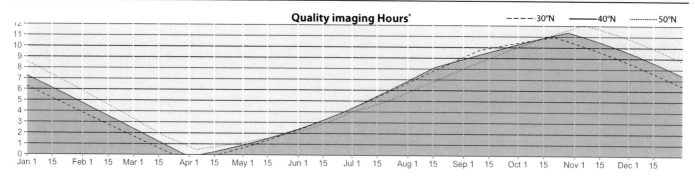

Quality imaging Hours*

--- 30°N —— 40°N ········ 50°N

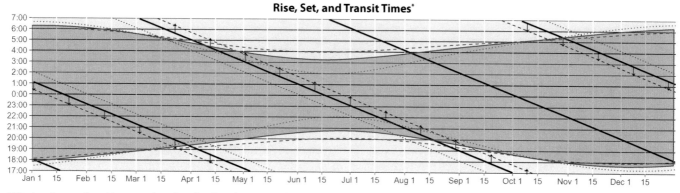

Rise, Set, and Transit Times*

* Rise/set times and total hours are based on the object being >15° above the horizon. Darkness defined as when the sun is >12° below horizon

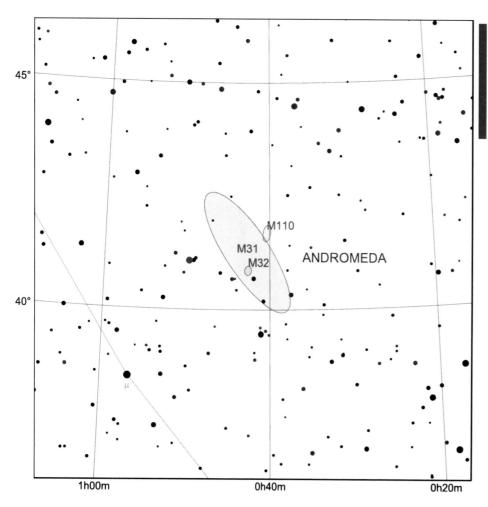

One of the finest imaging targets in the night sky. Spanning 3 degrees and visible with the naked eye, even short exposures show the basic structure. Long integration times and careful processing reveal dust lanes, subtle colors, and HII regions.

The Sculptor Galaxy (NGC253)

Type: Galaxy

Size: 28'×7'

Coordinates: 00h 47m, -25° 17'

Cataloged as: NGC253, Silver Dollar Galaxy

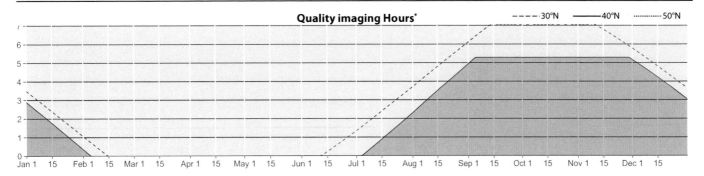

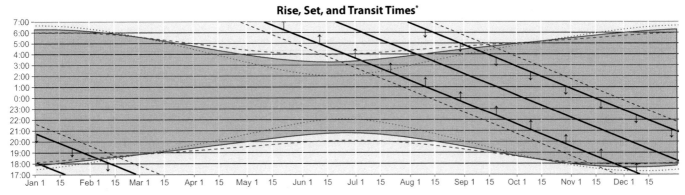

* Rise/set times and total hours are based on the object being >15° above the horizon. Darkness defined as when the sun is >12° below horizon

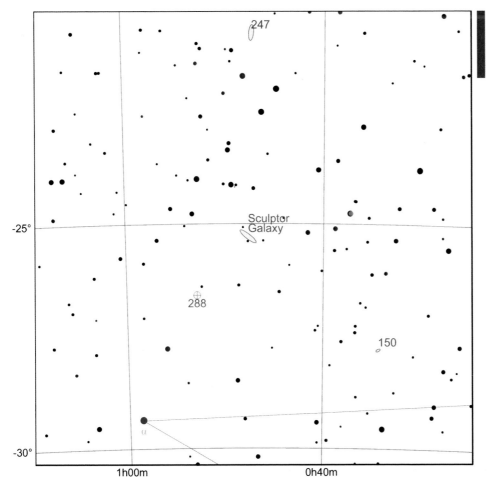

The large and bright Sculptor Galaxy is a highlight galaxy for more southern imagers. A huge galaxy at 28'x7' with detail throughout the arms.

The Pacman Nebula (NGC281)

Type: Emission Nebula

Size: 35'×35'

Coordinates: 00h 53m, +56° 35'

Cataloged as: Sh2-184, NGC281, IC1590

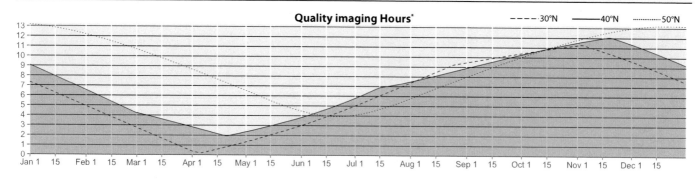

Quality imaging Hours*

– – – 30°N —— 40°N ⋯⋯⋯ 50°N

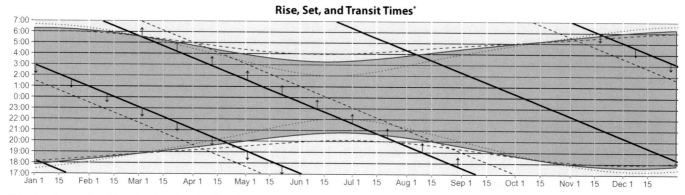

Rise, Set, and Transit Times*

* Rise/set times and total hours are based on the object being >15° above the horizon. Darkness defined as when the sun is >12° below horizon

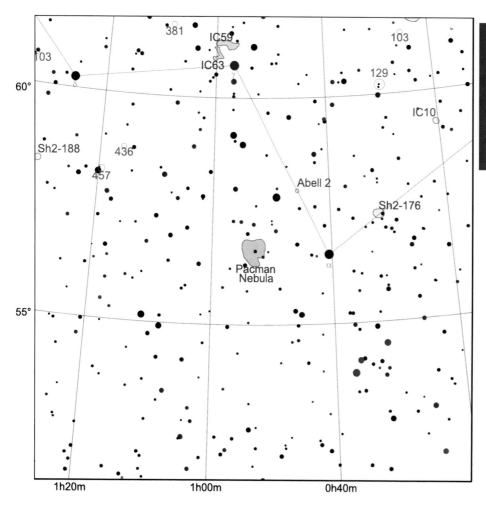

Similar to the Wizard Nebula, but a little larger, NGC281 is a great target for both RGB and narrowband approaches. Long focal lengths reveal tendrils and Bok globules, as well as lots of detail in the dust lanes that for Pacman's "mouth." Good OIII signal in the central area. IC1590 is the associated open cluster.

The Ghosts of Cassiopeia (IC59 and 63)

Type: Reflection Nebula

Coordinates: 00h 59m, +60° 57'

Size: 15'×18'

Cataloged as: vdB 5, Sh2-185

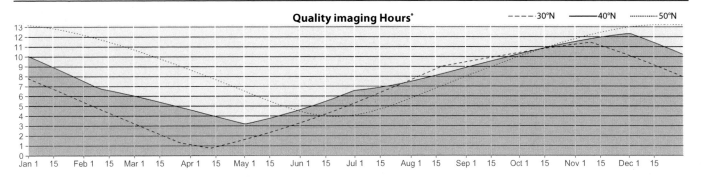

Quality imaging Hours*

--- 30°N ——— 40°N 50°N

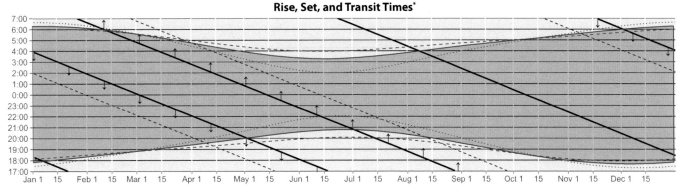

Rise, Set, and Transit Times*

* Rise/set times and total hours are based on the object being >15° above the horizon. Darkness defined as when the sun is >12° below horizon

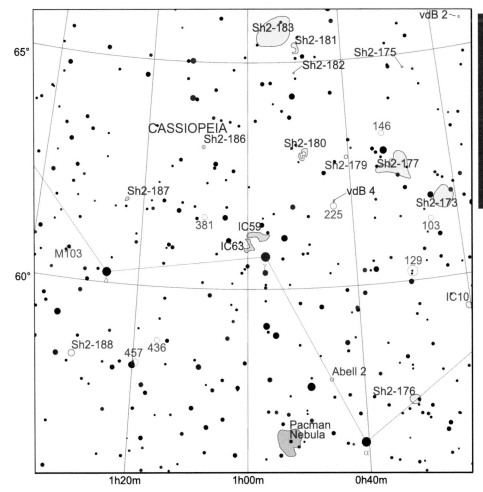

Technically, Sh2-185 and vdB 5 both describe this pair of objects, but they are usually referred to by their IC designations 59 and 63. Both are emission nebula with reflection components from 2nd magnitude Gamma Cassiopeiae, especially for IC 59. 60' captures both. H-alpha enhances contrast, but a good target for RGB as well. Nearby nebulae and clusters make this entire Cassiopeia area suitable for widefield imaging.

The Triangulum Galaxy (M33)

Type: Galaxy

Size: 1.2°×0.7°

Coordinates: 01h 33m, +30° 39'

Cataloged as: NGC598

Quality imaging Hours*

- - - - 30°N —— 40°N 50°N

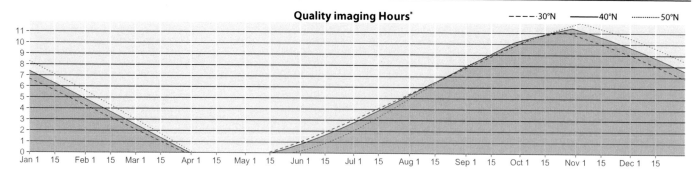

Rise, Set, and Transit Times*

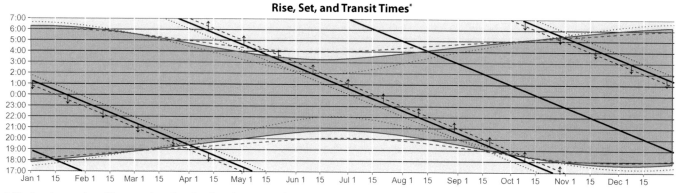

* Rise/set times and total hours are based on the object being >15° above the horizon. Darkness defined as when the sun is >12° below horizon

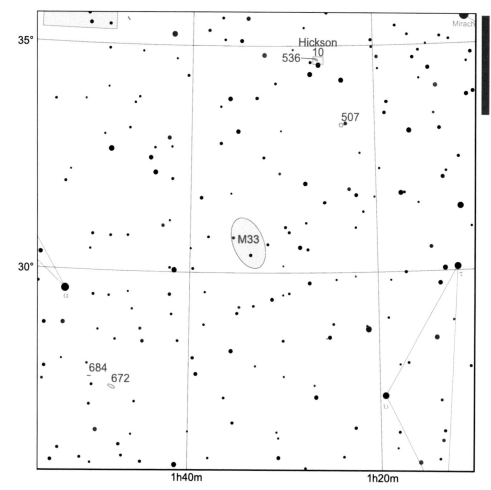

The Triangulum Galaxy's low surface brightness makes it surprisingly challenging to process despite its size. It has prominent HII regions, which can be enhanced by incorporating H-alpha data into an RGB image.

NGC891

Type: Galaxy

Size: 14'×3'

Coordinates: 02h 22m, +42° 21'

Cataloged as:

Quality imaging Hours*

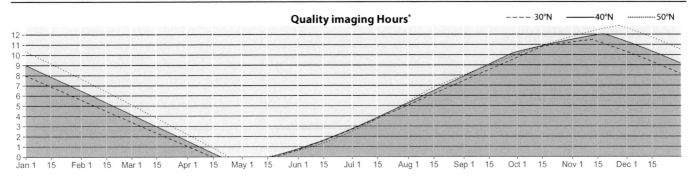

- - - - 30°N —— 40°N ········· 50°N

Rise, Set, and Transit Times*

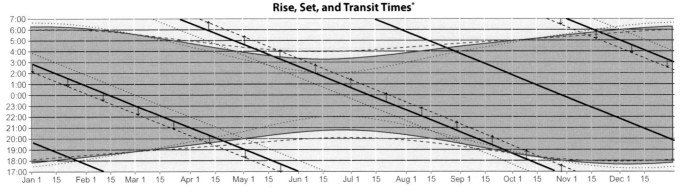

* Rise/set times and total hours are based on the object being >15° above the horizon. Darkness defined as when the sun is >12° below horizon

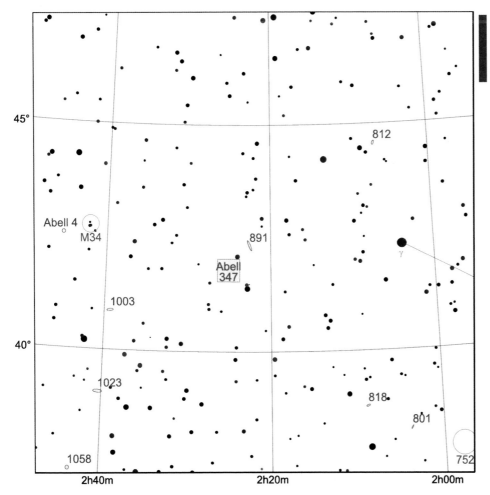

NGC891 is one of the finest edge-ons galaxies due to its wide dust lane. Clear skies and deconvolution reveal fine details in the central lane.

The Heart and Soul Nebulae

Type: Emission Nebula

Size: 2.1°×1.4° (Soul), 2.5°×2.5° (Heart)

Coordinates: 02h 45m, +60° 50'

Cataloged as: Sh2-199, IC1848 (Soul); Sh2-190, IC1805 (Heart); NGC896 (IC1795)

Quality imaging Hours*

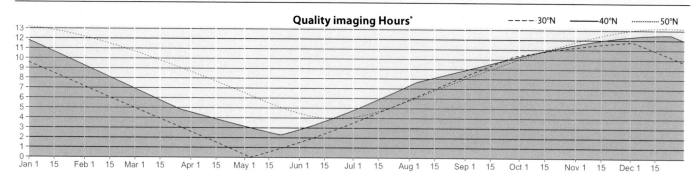

Rise, Set, and Transit Times*

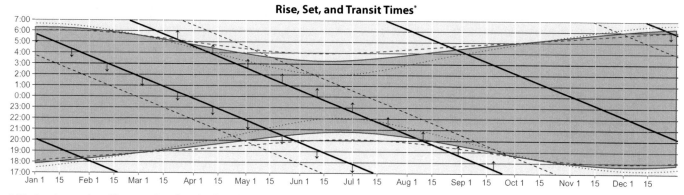

* Rise/set times and total hours are based on the object being >15° above the horizon. Darkness defined as when the sun is >12° below horizon

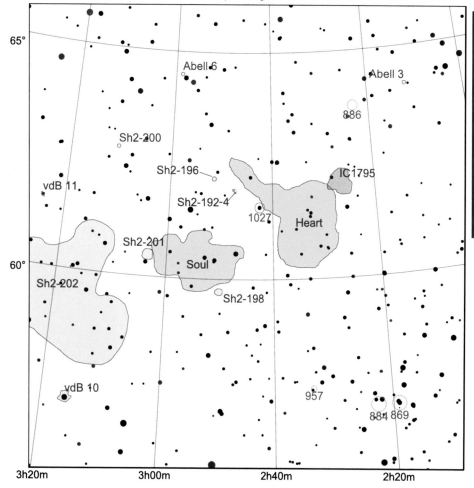

Two great narrowband objects right next to each other. Both have complex structure in H-alpha, SII, and OIII. A 6° FOV is required to capture both, about 3 degrees for each (The Heart is larger than the Soul). IC1795 is attached to the Heart Nebula, and further subdividing things, the bright, western side of IC1795 is cataloged as NGC 896. The central star cluster of the Heart is known as Melotte 15, and the surrounding knot of nebulosity is an exceptional target for long focal lengths.

Type: Reflection Nebula **Coordinates:** 03h 29m, +31° 23'

Size: 14'×15' **Cataloged as:** vdB 17

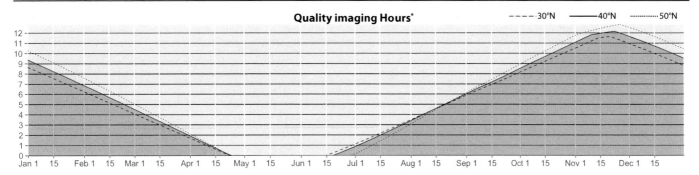

Quality imaging Hours*

– – – – 30°N ——— 40°N ·········· 50°N

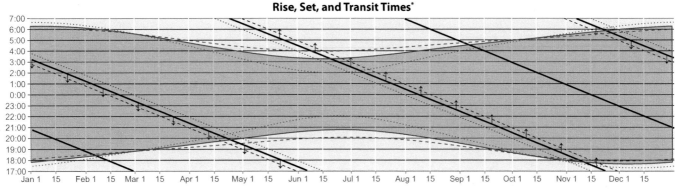

Rise, Set, and Transit Times*

* Rise/set times and total hours are based on the object being >15° above the horizon. Darkness defined as when the sun is >12° below horizon

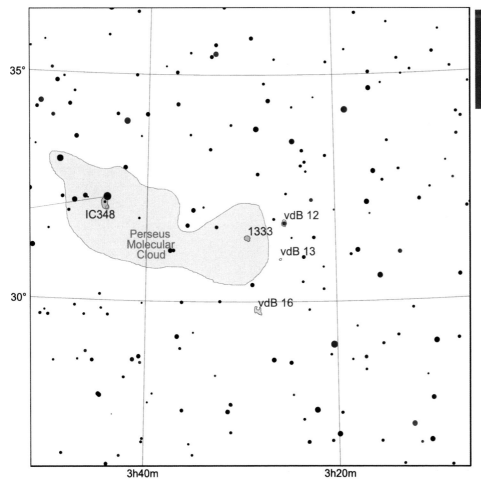

Small but beautiful combination of blue reflection nebulae with dark dust lanes, and red Herbig-Haro objects. If you have dark skies, you can capture a wider field that shows its context as part of the Perseus Molecular Cloud.

IC342

Type: Galaxy
Size: 21'×21'

Coordinates: 03h 46m, +68° 05'

Cataloged as:

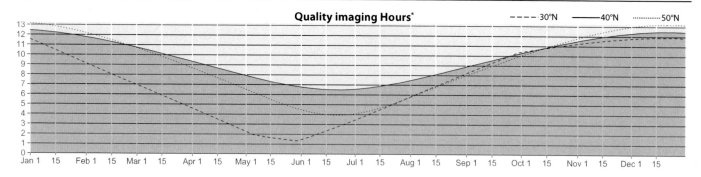

Quality imaging Hours*

- - - - 30°N —— 40°N ·········· 50°N

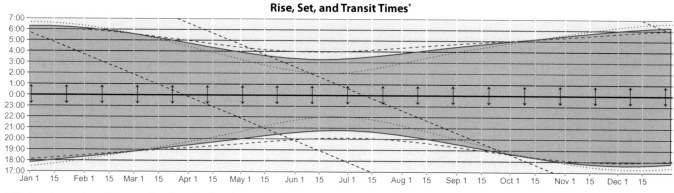

Rise, Set, and Transit Times*

* Rise/set times and total hours are based on the object being >15° above the horizon. Darkness defined as when the sun is >12° below horizon

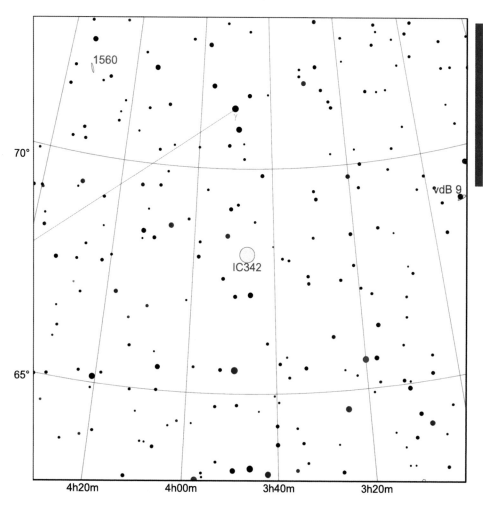

IC342 is a faint, face-on spiral. While not the easiest to image, its high declination makes it a good target year-round. It is large, but very dim due to our having to view it through the Milky Way's dust, hence its IC designation (it was completely missed by the Herschels' visual observations for the NGC catalogs). NGC1560 is an edge-on spiral a few degrees away.

The Pleiades

Type: Reflection Nebula

Size: 35'×35'

Coordinates: 03h 47m, +24° 10'

Cataloged as: M45, vdB 23

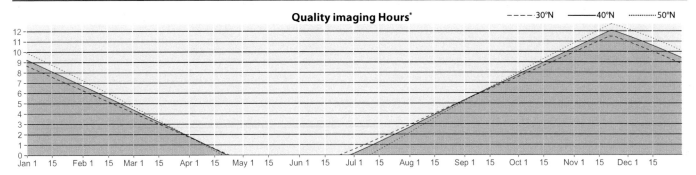

Quality imaging Hours*

- - - - 30°N —— 40°N ········ 50°N

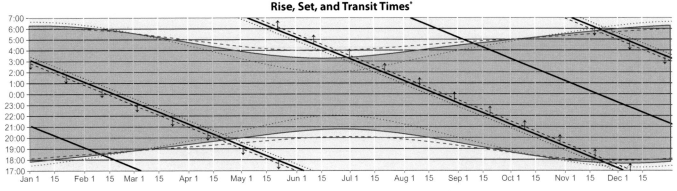

Rise, Set, and Transit Times*

* Rise/set times and total hours are based on the object being >15° above the horizon. Darkness defined as when the sun is >12° below horizon

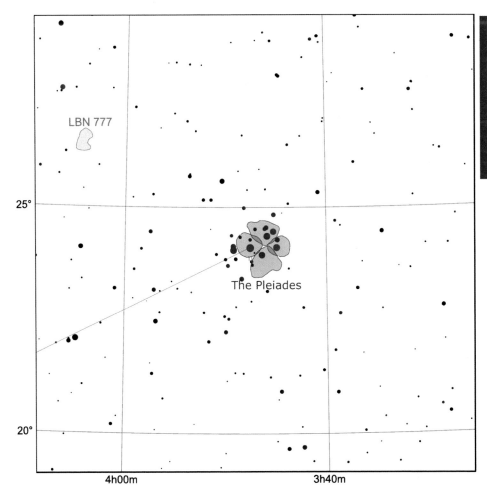

Easily visible to the naked eye, the Pleiades (M45) are a bright open cluster illuminating a wispy reflection nebula complex. Wider and deeper images can reveal the much larger Taurus molecular cloud that M45 illuminates only a part of. Careful processing should easily bring out the streaky nature of the nebulosity, especially around Merope.

Type: Emission Nebula

Size: 3.0°×2.1°

Coordinates: 04h 01m, +36° 15'

Cataloged as: Sh2-220, NGC1499

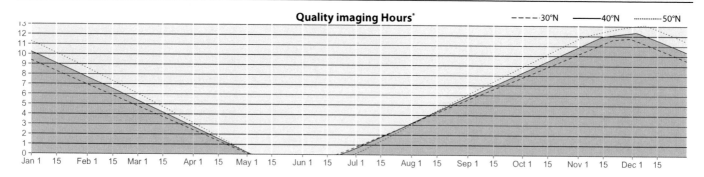

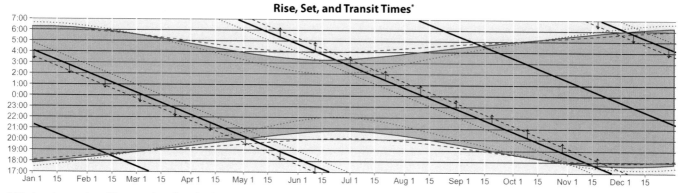

* Rise/set times and total hours are based on the object being >15° above the horizon. Darkness defined as when the sun is >12° below horizon

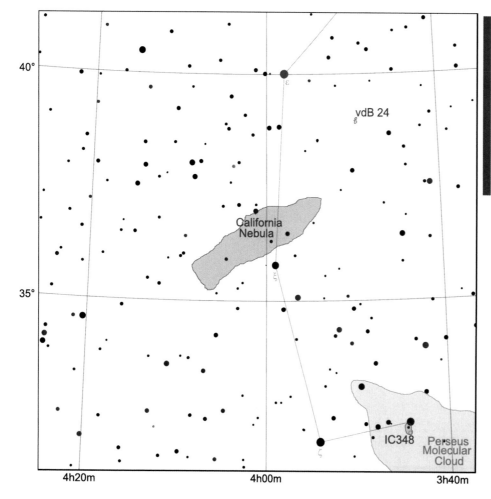

The California Nebula (NGC1499) is a deep-sky highlight in RGB color or narrowband. It's a huge, bright emission nebula with H-alpha, SII, and OIII signal spread across a rippled surface. Additional time spent on OIII is rewarded. Due to its low surface brightness, it was not discovered until 1884 (by Barnard), but it is now a commonly imaged object by amateurs.

Sh2-206

Type: Emission Nebula

Size: 17'×21'

Coordinates: 04h 03m, +51° 20'

Cataloged as: NGC1491

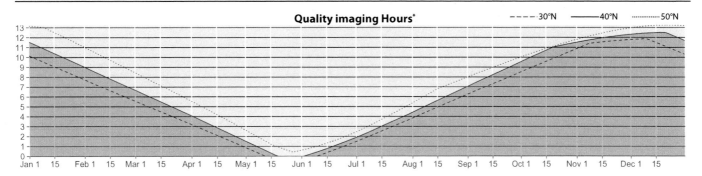

Quality imaging Hours*

- - - 30°N —— 40°N ·········· 50°N

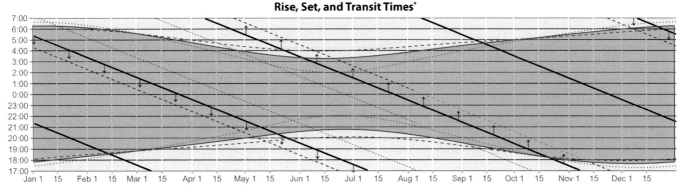

Rise, Set, and Transit Times*

* Rise/set times and total hours are based on the object being >15° above the horizon. Darkness defined as when the sun is >12° below horizon

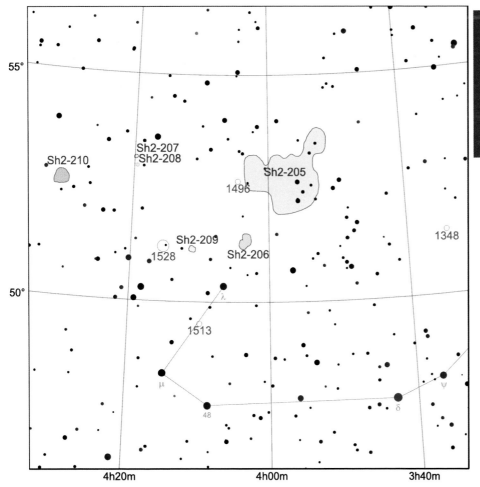

Sh2-206 it an infrequently imaged emission nebula with a bright OIII core and H-alpha and SII signal throughout. The cluster at center is NGC1491. It is almost attached to the much larger, though fainter, Sh2-205, which is about 4° across, providing the opportunity for a widefield approach here as well.

The Witch's Head Nebula

Type: Reflection Nebula

Size: 1.5°×2.0°

Coordinates: 05h 05m, -07° 06'

Cataloged as: NGC1909, IC2118, vdB 36, Ced 41A

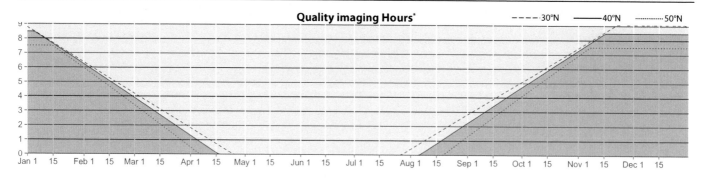

Quality imaging Hours*

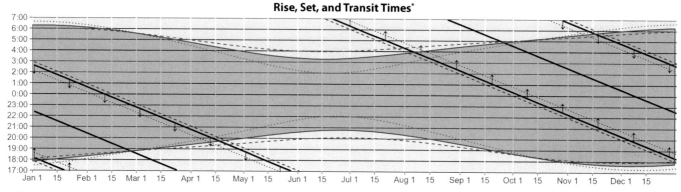

Rise, Set, and Transit Times*

* Rise/set times and total hours are based on the object being >15° above the horizon. Darkness defined as when the sun is >12° below horizon

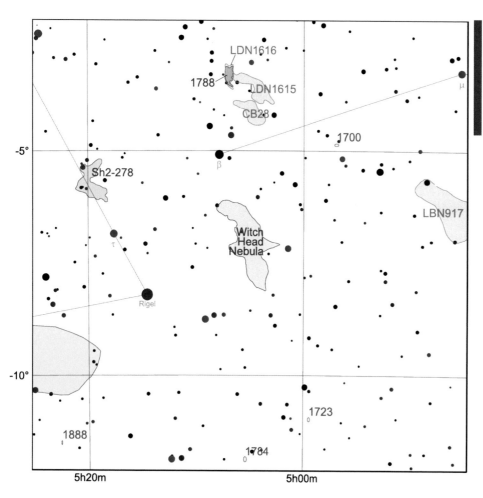

IC2118 is a reflection nebula lit by very bright Rigel, the left foot of Orion. Spanning almost 3 degrees, it's huge but faint. Be careful capturing Rigel in the same FOV, as its glow can obscure IC2118. Dimmer psi and lamda Eridani flank either side.

The Flaming Star, the Spider, and the Fly

Type: Emission Nebula

Size: 2°×2°

Coordinates: 05h 18m, +33° 45'

Cataloged as: Sh2-229, IC405, IC410, vdB 34

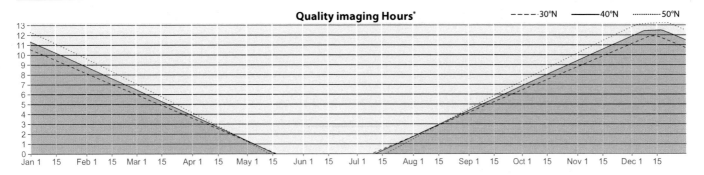

Quality imaging Hours*

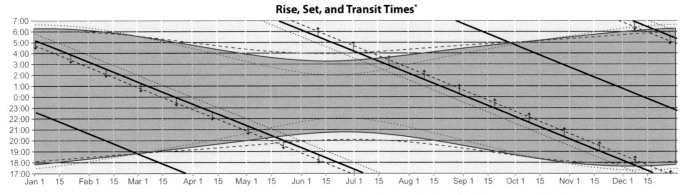

Rise, Set, and Transit Times*

* Rise/set times and total hours are based on the object being >15° above the horizon. Darkness defined as when the sun is >12° below horizon

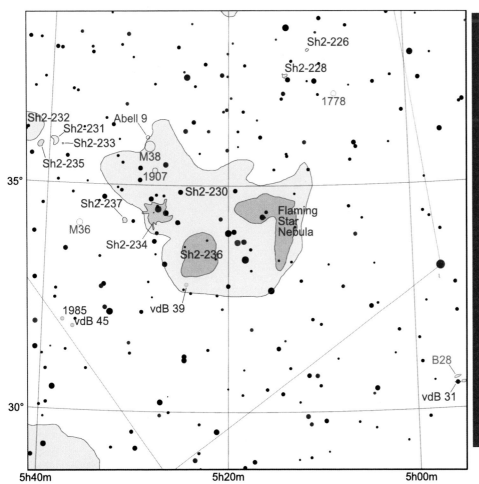

The Flaming Star Nebula (IC405, Sh2-229) is a bright emission nebula with a reflection component in center (vdb 34), lit by the star AE Aurigae. H-alpha, SII, and OIII signals are all present, though the SII and OIII are faint. Nearby is the arguably more photogenic IC410 (Sh2-236), which features not only stronger SII and OII signals and an embedded open cluster (NGC1893), but two tadpole-shaped structures that are likely star forming regions. Wider FOVs capture both nebulae together as part of a larger structure (actually cataloged by Sharpless as Sh2-230) and other nearby nebulae like Sh2-234. Narrow FOVs are best aimed at the tadpoles and core of IC410. Sh2-234 and 237 are playfully known as the Spider (Sh2-234) and the Fly (smaller Sh2-237) when captured together. They are fairly bright, wispy nebulae within a one-degree FOV. SII is bright around the core of the Spider, with OIII diffuse throughout. NGC1931 is the cluster embedded within the Fly.

The Crab Nebula

Type: Emission Nebula

Size: 7'×6'

Coordinates: 05h 34m, +22° 01'

Cataloged as: M1, Sh2-244, NGC1952

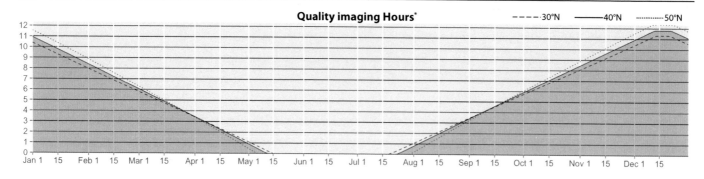

Quality imaging Hours*

 ---- 30°N ——— 40°N ······ 50°N

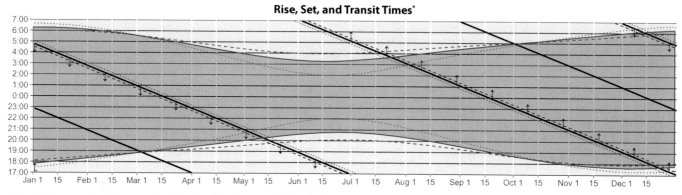

Rise, Set, and Transit Times*

* Rise/set times and total hours are based on the object being >15° above the horizon. Darkness defined as when the sun is >12° below horizon

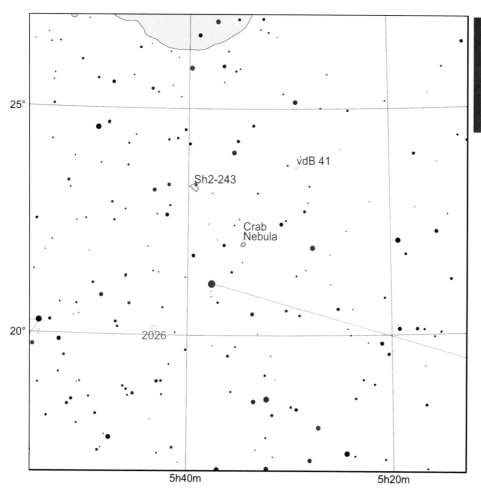

M1 is the famous remnant of a supernova observed in 1054. Larger telescopes are needed to reveal the tiny filamentary details. RGB imaging shows a bold orange on blue contrast. Rarely used filters like Helium and NII may distinguish different features.

The Orion and Running Man Nebulae

Type: Emission Nebula

Size: 60'×55' (M42), 30'×25' (Sh2-279)

Coordinates: 05h 36m, -05° 00'

Cataloged as: Sh2-281, NGC1976 (M42); NGC1973/1975/1977, Ced 55B/C (Sh2-279)

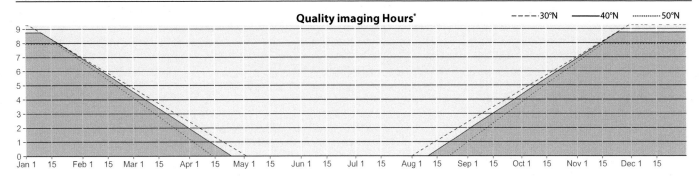

Quality imaging Hours*

--- 30°N ⎯⎯ 40°N ⋯⋯ 50°N

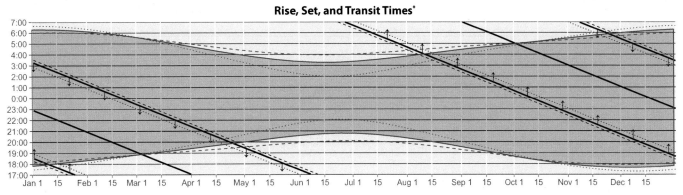

Rise, Set, and Transit Times*

* Rise/set times and total hours are based on the object being >15° above the horizon. Darkness defined as when the sun is >12° below horizon

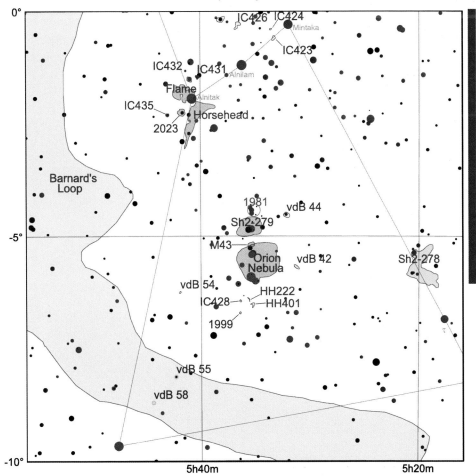

The Orion Nebula (M42) is the brightest nebula in the night sky, and it was the target for the first deep sky image ever taken (Henry Draper, 1880). It is also usually the first target for many amateur astrophotographers. An easy target with even short exposures. Pinks and greens are easily revealed from the emission and reflection components. One of the few objects bright enough to require different exposure lengths to capture its full dynamic range. The nearby Running Man nebula (Sh2-279) features several bright stars within bright nebulosity, and is usually captured in the same field of view as M42.

Type: Emission Nebula

Size: 0.7°×1.0° (Horsehead), 30'×25' (Flame)

Coordinates: 05h 40m, -02° 10'

Cataloged as: IC434, B33 (Horsehead); Sh2-277, NGC2024, Ced 55P (Flame)

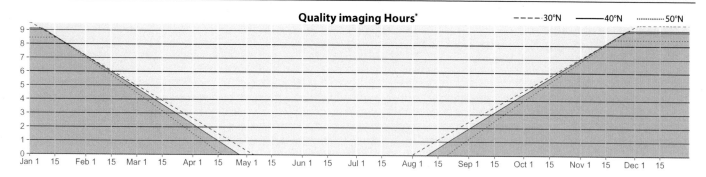

Quality imaging Hours*

- - - - 30°N ——— 40°N ·········· 50°N

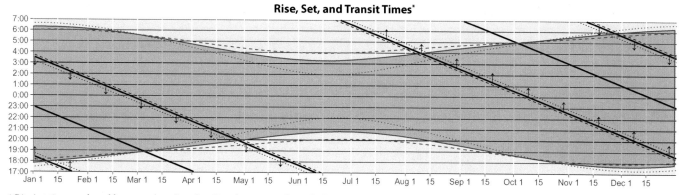

Rise, Set, and Transit Times*

* Rise/set times and total hours are based on the object being >15° above the horizon. Darkness defined as when the sun is >12° below horizon

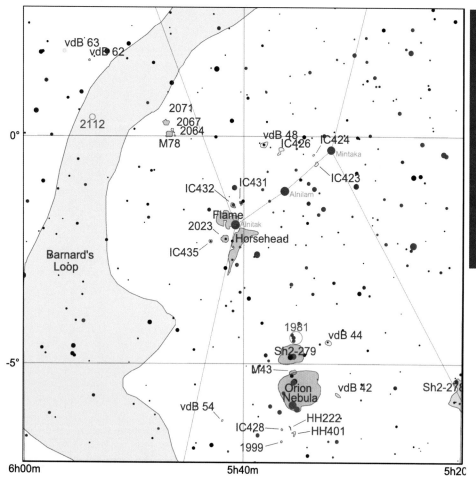

Alnitak illuminates two fantastic nebulae: the Horsehead glows brightly in H-alpha red, with a dark horse head shape carved out of one side (Barnard 33). Narrowband filters are not required, but they will bring out faint wispy structure more clearly. The Flame Nebula is a very bright emission nebula on the other side of Alnitak that is usually captured in same field of view. The Flame has its own central dark nebula, though less distinct than B33. Two degrees north is bright blue reflection nebula M78, with an arc of dark nebula (LDN 1630) cutting across it.

Barnard's Loop

Type: Emission Nebula

Size: 10.9°×14.7°

Coordinates: 05h 40m, -03° 04'

Cataloged as: Sh2-276

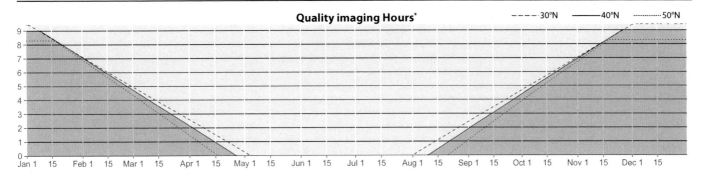

Quality imaging Hours*

- - - - 30°N ——— 40°N ········· 50°N

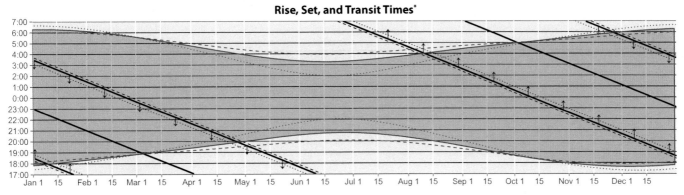

Rise, Set, and Transit Times*

* Rise/set times and total hours are based on the object being >15° above the horizon. Darkness defined as when the sun is >12° below horizon

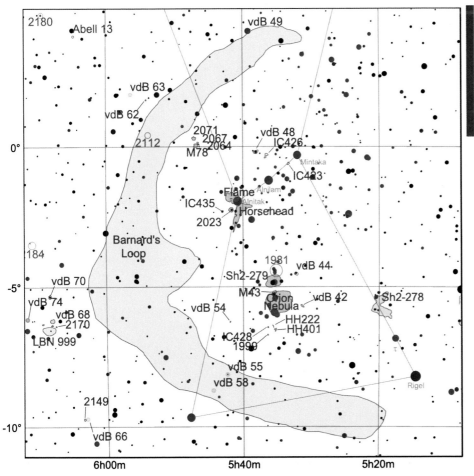

Barnard's Loop is a gigantic semicircle of H-alpha around Orion. It requires a camera lens to image due to its enormous size. Very dim, but easily revealed with an H-alpha filter. (Note: to accommodate its size, this map is 16°×16°, 1.6 times the size of the other maps.)

Simeis 147

Type: Emission Nebula

Size: 3.6°×3.4°

Coordinates: 05h 40m, +27° 58'

Cataloged as: Sh2-240

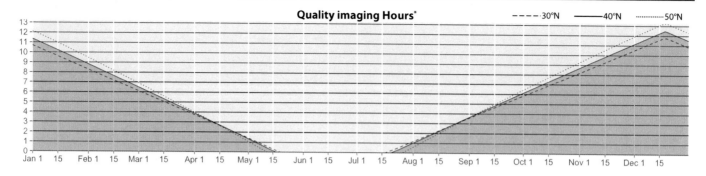

Quality imaging Hours*

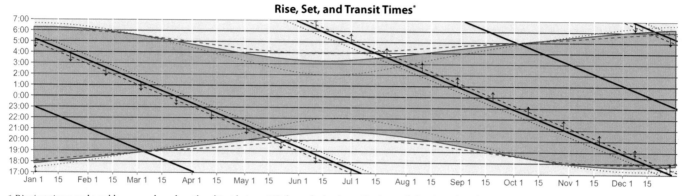

Rise, Set, and Transit Times*

* Rise/set times and total hours are based on the object being >15° above the horizon. Darkness defined as when the sun is >12° below horizon

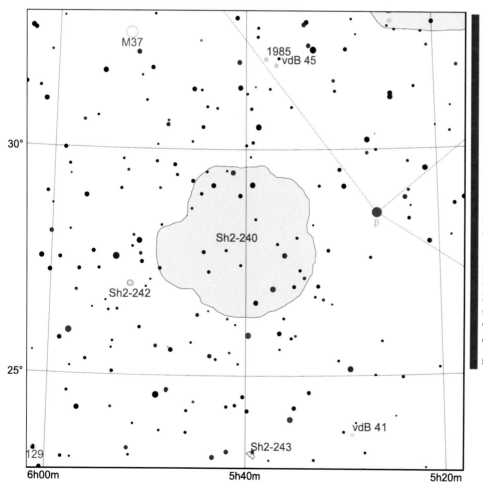

This supernova remnant, sometimes called the Spaghetti Nebula, spans about 3.3 degrees and has an intricate, looping structure (see the back cover). Its faintness makes it a challenging target for RGB imaging, but an H-alpha filter reveals it with long exposures. Be sure to use a long enough subexposure time to ensure good signal-to-noise ratio; this object may require longer than usual exposure time. It also has distinct areas of OIII signal, though this is even dimmer than the H-alpha, so both filters are required to capture its full structure. Despite being cataloged by Sharpless, it is known by the obscure Simeis catalog number, named after the Crimean observatory in Simeiz. The bright star nearby is Elnath (Beta Tauri), and the bright circular emission nebula to the west is Sh2-242.

NGC2170

Type: Reflection Nebula

Size: 50'×50'

Coordinates: 06h 07m, -06° 24'

Cataloged as: vdB 67, Ced 63

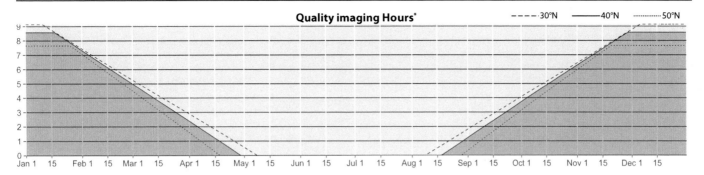

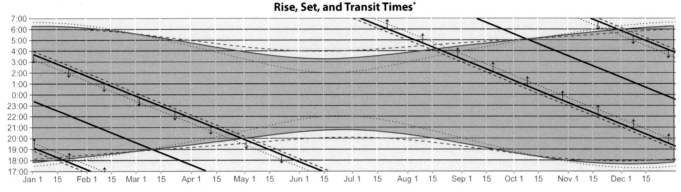

* Rise/set times and total hours are based on the object being >15° above the horizon. Darkness defined as when the sun is >12° below horizon

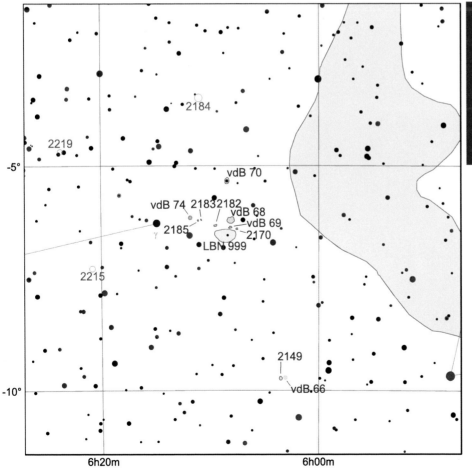

A celestial smorgasbord, this small area features streaks of dust across overlapping blue and red nebulae. NGC2170 is the prominent reflection nebula, but it is surrounded by vdB 67-69 and LBN 999, among others. It's a challenging area to image, but the range of colors and shapes make it a highlight for longer focal lengths with RGB filters.

Lower's Nebula (Sh2-261)

Type: Emission Nebula **Coordinates:** 06h 09m, +15° 44'

Size: 55'×40' **Cataloged as:** Sh2-261

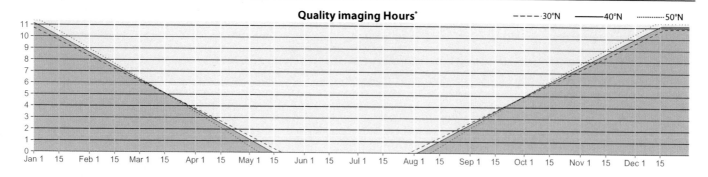

Quality imaging Hours*

- - - - 30°N —— 40°N ⋯⋯ 50°N

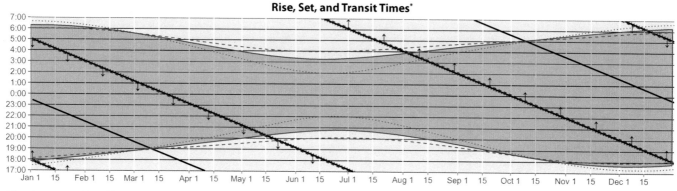

Rise, Set, and Transit Times*

** Rise/set times and total hours are based on the object being >15° above the horizon. Darkness defined as when the sun is >12° below horizon*

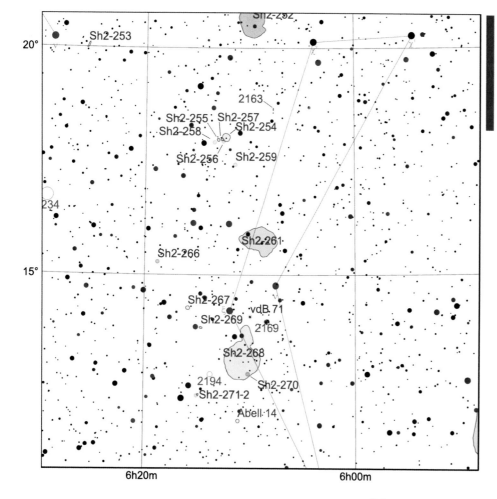

A bright nebula with a structure similar to the Lagoon Nebula (though much smaller) that is neglected by most imagers due to the number of nearby nebulae. Good SII and OIII signal make a mapped-color image possible.

The Jellyfish and Monkey's Head Nebulae

Type: Emission Nebula

Coordinates: 06h 16m, +22° 28'

Size: 50'×55'

Cataloged as: Sh2-248, IC443 (Jellyfish); IC444 (Sh2-249); NGC2174/2175, IC2159, Ced 67A (Monkey's Head)

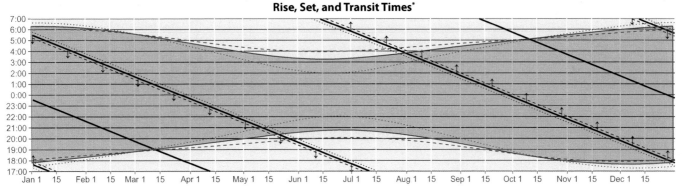

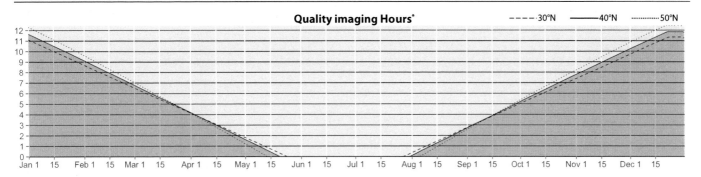

* Rise/set times and total hours are based on the object being >15° above the horizon. Darkness defined as when the sun is >12° below horizon

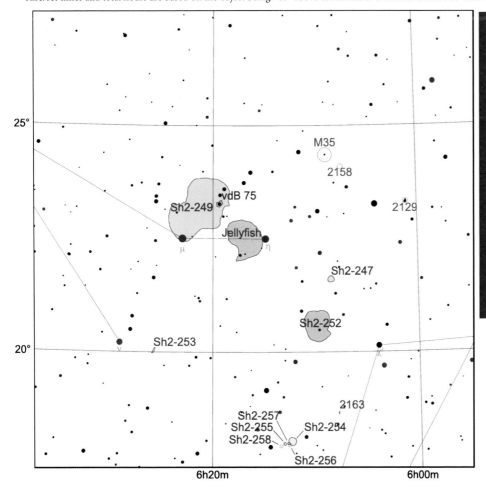

The Jellyfish Nebula (IC443) is a huge and bright supernova remnant, with tendrils that make it truly look like a jellyfish. Works well in RGB or narrowband. Fainter Sh2-249 is next door and attached, with some dust lanes that make it interesting. Together, the objects make a nice deep-sky scene, especially with bright stars Mu and Eta Geminorum. Nearby Sh2-252 is sometimes called the Monkey's Head Nebula, and it is another great narrowband target, with H-alpha and enough SII, and OIII to provide nice color contrast. It is often overlooked due to the other spectacular nebulae nearby, and since it's a little smaller, it makes a better target for longer focal lengths.

The Rosette Nebula

Type: Emission Nebula

Size: 1.7°×1.4°

Coordinates: 06h 32m, +04° 57'

Cataloged as: Sh2-275, NGC2246

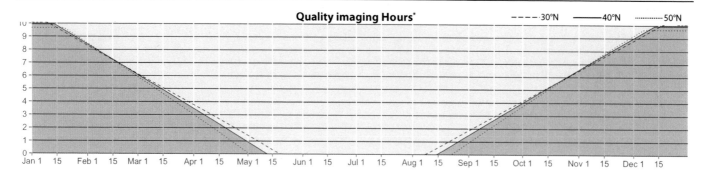

Quality imaging Hours*

- - - 30°N ——— 40°N ········· 50°N

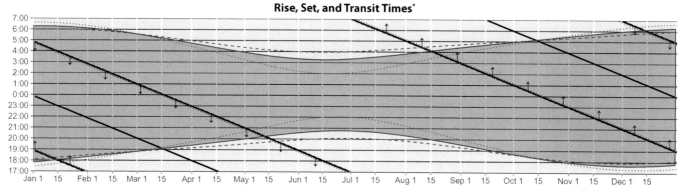

Rise, Set, and Transit Times*

* Rise/set times and total hours are based on the object being >15° above the horizon. Darkness defined as when the sun is >12° below horizon

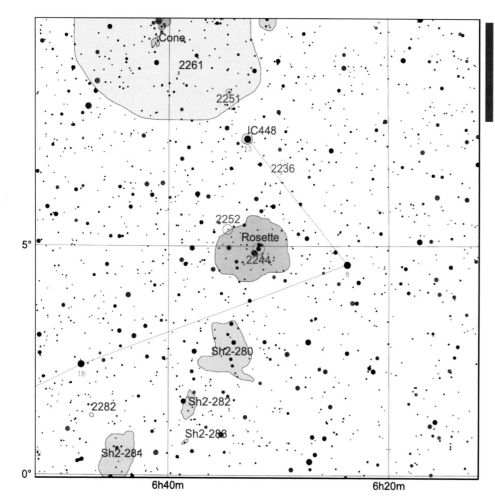

Great in RGB, but brilliant in narrowband, the Rosette Nebula has an incredibly photogenic structure, with detail revealed at any focal length. NGC 2244 is the cluster behind the nebulosity.

Type: Emission and Reflection Nebulae

Coordinates: 06h 40m, +09° 50'

Size: 16'×16'

Cataloged as: NGC2264, Ced 84B

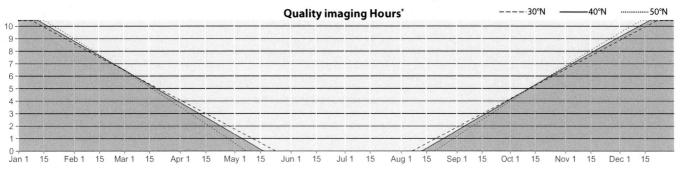

Quality imaging Hours*

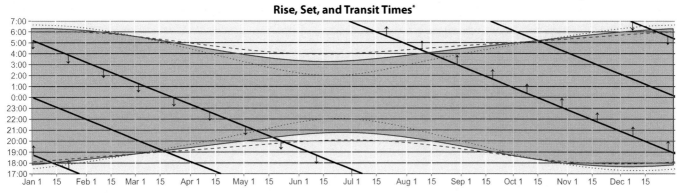

Rise, Set, and Transit Times*

* Rise/set times and total hours are based on the object being >15° above the horizon. Darkness defined as when the sun is >12° below horizon

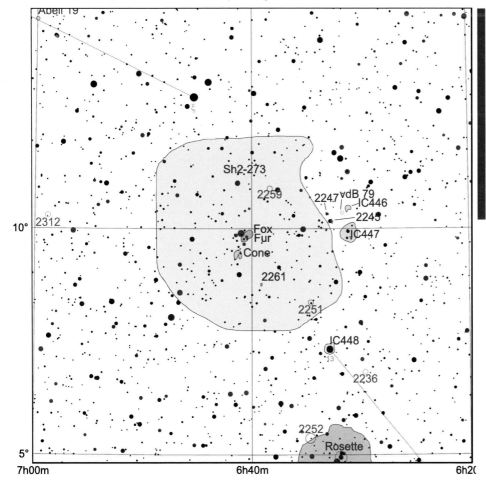

The greater area of nebulosity that contains the Cone and Fox Fur Nebulae is cataloged as Sh2-273 and known colloquially as the Christmas Tree Cluster, referring to the embedded open cluster NGC2264. The obvious Cone Nebula sits at one end, a protrusion into the larger nebula. The Fox Fur Nebula sits at the other end, an interesting mix of emission, reflection, and dust nebulae. (Supposedly, this nebula looks like a fox fur shawl, and somehow the name has stuck.)

Appendix: Sensor FOV Templates for Common Focal Lengths

Four common sensor sizes are shown below with the field of view for each when matched with some common focal lengths. These are printed at the same scale (0.9° per cm) as the maps used throughout this book, with the exception of the map for Barnard's Loop. You can use these with a ruler or copy them onto transparency film to estimate your FOV on the maps.

Full Frame (36×24 mm)

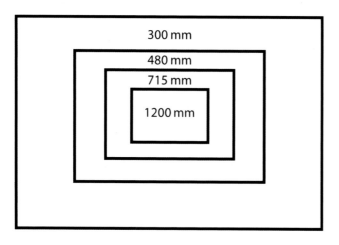

4/3" (17.7×13.4 mm)

APS-C (23.6×15.6 mm)

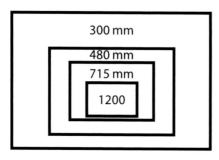

1" (13.2×8.8 mm)

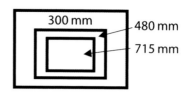

Index of Objects

90

80263017R00053